Watercolor for the Soul

SIMPLE PAINTING PROJECTS FOR BEGINNERS, TO CALM, SOOTHE, AND INSPIRE

Sharone Stevens

Contents

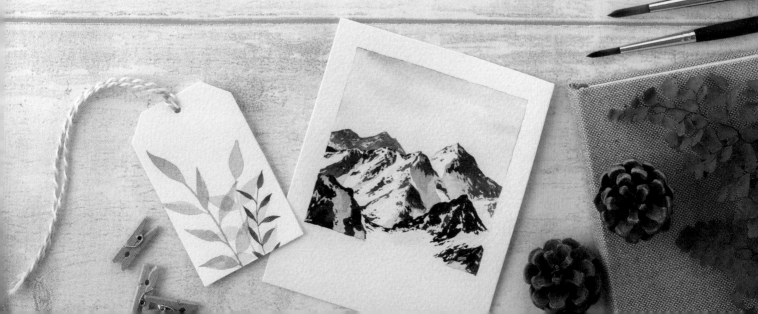

Introduction

Painting with watercolor is one of my favorite ways to relax and unwind, and to find peace in the rush of everyday life. With its uniquely transparent colors and soft, unpredictable blends, it is a beautiful, enchanting medium that has the potential to nourish our minds and souls as we paint, connecting us to the abundance of beauty and inspiration in the world around us. It has the ability to transform something ordinary, an everyday object, into something captivating on the paper.

This book was born out of my desire to share my love of watercolor with you; to encourage and inspire you to have a regular, creative practice that provides a way to relax and feel joy. I am passionate about showing you how watercolor can be a wonderfully beneficial, mindful activity that can be accessible while also being satisfying and rewarding. It does not need to be complicated. Even painting simple lines and shapes, concentrating on each brush stroke, can be incredibly therapeutic and calming.

I have always enjoyed being creative and have explored many different hobbies over the years. There is something special about creating by hand, no matter what it is and no matter how small or simple it may be. It allows us to concentrate our focus as we watch something develop before our eyes, something personal and unique made from our own hands.

These days, it is so common to bombard ourselves with noise and distractions from our phones, social media, news, and the internet. It is all constantly vying for our attention. I believe we are all naturally creative as humans but, as we grow up, responsibilities, noise, and stress from the world around us can stifle that creativity. Watercolor, for me, is a way to switch off and break away from that noise. To be more mindful as I concentrate on simple brush strokes or watch the water carry the paint across the page. It also gives us the opportunity to interpret the world around us in our own unique way, telling a story through a painting and expressing our emotions on the page.

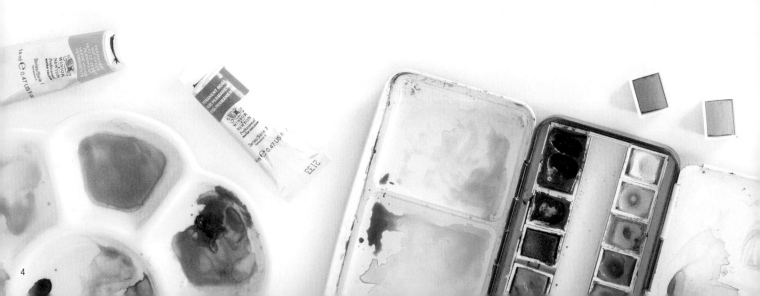

In this book, we start with the foundations to set you up in the best possible way to understand and enjoy watercolor—from mindset tips, to basic techniques, exercises, and color theory. Later in the book you will find a variety of projects that I have broken down into simple steps for you. Some of the projects are quick and easy, perfect for when you have just a small amount of time or just want something simple and relaxing to paint. Then there are some longer, more detailed projects that you can lose yourself in and stretch your skills with. I have chosen projects that I believe will not only be achievable as you learn, but that will also feel relaxing to paint, from patterns and textures, to food, animals, landscapes, and botanicals. Whether it be from the subject itself, the colors, the type of brush strokes you use, or the repetition involved, I hope you will find the projects relaxing too. These topics are some of the things that inspire me the

most and my goal is that they will encourage you to open your eyes more to the abundance of inspiration that surrounds you in your everyday world as well.

Whether you're new to watercolor or more experienced, I hope this book will be a valuable part of your watercolor journey—helping you to build a wonderful, relaxing hobby and encouraging you to make it a regular and meaningful part of your life.

Happy painting!

Sharone

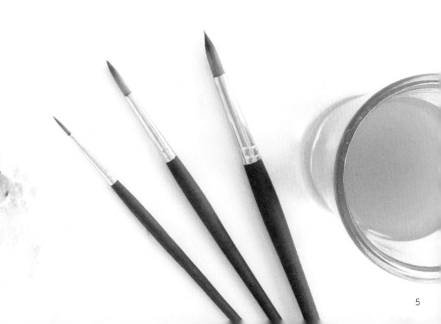

Connecting with your practice

To truly relax with watercolor, or with any creative hobby, we must first become more aware of ourselves, our thoughts, and our surroundings. The following tips are things that have helped me to approach my art in the most relaxing way possible. I hope you will find them helpful too.

FOCUS ON YOUR BREATHING

Focusing on our breathing is one of the quickest and easiest ways to calm ourselves. The more stressed we feel, the faster we tend to breathe. So intentionally slowing our breathing tells our brain that everything is okay and that we are in a place of calm. It can have a surprisingly immediate effect on how we feel. When I first sit down to paint, I spend a couple of minutes just focusing on my breathing, and I encourage you to do the same. Take a deep breath in for a count of four, hold for four, and then breathe out for four. Repeat this a few times. Throughout your painting session, make sure you keep coming back to your breathing, checking that you're not holding your breath as you paint. Become aware of any tension in your body and make sure to relax your shoulders. You may wish to add a little note to your desk to remind yourself of this every time you sit down to paint!

CREATE SPACE, MENTALLY AND PHYSICALLY

Our brain is constantly responding to the world around us. The more we have to process, the harder it can be to relax and be mindful while we paint. I like to clear any physical clutter from my desk before I start painting, keeping out only those supplies that I will need. If my mind is feeling busy, I also find it useful to grab a pen and paper and write down all of my thoughts or my "to-do" list. You can then put them to one side, knowing that they are in a safe place and you can forget about them for a while and focus on your painting.

When I first sit down to paint, I spend a couple of minutes just focusing on my breathing.

MAKE YOUR SPACE COMFORTABLE AND INSPIRATIONAL

Beyond your desk, surround yourself with things you love and that inspire you. Make your painting area a motivating and comfortable place to be. This may mean having your favorite artwork on the wall or treasured books nearby. For me, I love having flowers and greenery around my home and near my desk, from small cacti to larger plant pots and dried flowers in a vase. If possible, position your desk next to a window for lots of natural light as well. This will make your desk feel even more expansive and joyful.

REMOVE DISTRACTIONS

I like to remove as many distractions as possible when I'm painting. This may include turning the television off or moving my phone out of reach. Try to disconnect from the noise around you and instead connect fully with your painting and how you feel. You'll be amazed at how much mental energy is taken up by constantly being distracted—a notification popping up on your phone or hearing the news in the background. Removing these things will help you to make the most of watercolor as a mindful activity.

PAY ATTENTION TO YOUR THOUGHTS

Becoming more aware of your thoughts—and therefore being more intentional with them—is one of the most important things you can do for relaxation. The aim is to prevent negative thoughts from creeping in. How will you ever enjoy the process if you keep telling yourself your work is terrible? How will you grow as an artist if you are telling yourself you cannot paint? Instead, every time you are painting, tell yourself that you are relaxing and you are learning. You are exploring and discovering new things. Using affirmations that begin with "I am…", like "I am calm", "I am relaxed", or "I am getting better at painting" can be incredibly powerful statements for our subconscious mind, affecting how we feel both mentally and physically. Choose how you want to feel, write down a few statements that reflect this, and repeat them in your head while you are painting. These will make you feel so much better than any negative thing that you might otherwise tell yourself!

Surround yourself with things you love and that inspire you.

FINDING INSPIRATION

It's quite common to get stuck with the question, "what shall I paint?" But the truth is that inspiration is all around us, we just need to learn to see it. For me, the best sources of inspiration are found in everyday life or in nature. Learning to become more aware of our surroundings and seeing the abundance of beauty and inspiration that is everywhere can be a magical feeling—notice the colors in the leaves, the texture in a tree trunk, the markings on a piece of fruit, and then think of ways to recreate them with watercolor. Keep your eyes open and start to look around you more to see what inspires you.

CHOOSING SUBJECTS

I find that simple or familiar topics are the most relaxing for me. What you choose to paint doesn't have to be challenging or complicated. There can be so much beauty in simplicity. I love to turn patterns, shapes, or simple landscapes into bookmarks, polaroids, or gift tags. They are fun, perfect for when I only have a little time to paint, and great for giving as gifts or keeping around the home. For these, I like to choose my favorite colors that I find calming to look at. These tend to be greens, blues, and dusky pinks. When I want to attempt something new or more challenging, I like to break it down into different elements like the colors, techniques, or composition, and explore them individually. This allows the process to be relaxing and enjoyable, and means that you can approach the final subject with much more confidence.

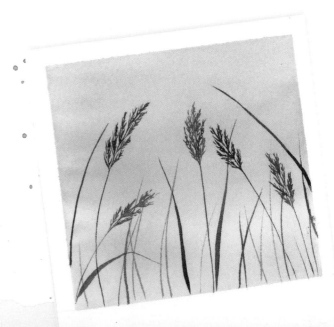

ENJOY THE PROCESS

An important part of relaxing with watercolor is learning to enjoy the process without putting too much pressure on the end result. Accept that not everything will turn out as you had hoped or expected. This is all part of learning and creating, and it can be really fun to explore your paints or different techniques. I have discovered wonderful things when I have been painting with no particular goal in mind: you may find a beautiful new color that you can mix, or a lovely harmonious combination that you never thought of before. The paint may react in an unpredictable way and inspire you to try a different style. There is something wonderful about just painting without purpose or pressure. You will discover more about what inspires you as an artist and discover and develop your own unique style.

KEEP A JOURNAL

I like to keep a journal dedicated to my watercolor journey. This is a great place to make notes about what has inspired you or things that you have learned. You can refer back to it later for ideas or to see the progress you have made. You can include quotes that motivate you or use it to doodle and swatch different colors. You can include anything that will help you to connect with your intention for painting and the way you want to feel when you sit down to paint.

KEEP IT SIMPLE AND JUST START

There is something beautiful about a blank piece of paper. After all, it holds the exciting potential of what it could turn into. But it can be hard to know how to approach it, which can lead to hesitation, procrastination, and even worry—all the things we want to avoid! If you have never painted with watercolor before and it feels daunting, my advice to you is to just make a start, no matter how small. Take some time to get to know your brushes, experimenting with how much water to use. Start exploring the basic techniques and brush strokes and then perhaps move on to some color mixing.

Above all else, remember that every stage is part of your journey. There will always be something else new and exciting for you to learn and explore as you paint, so enjoy every part of it and concentrate on where you are right now. As with learning anything new, there will inevitably be questions and challenges, but there will also be satisfaction, joy, and reward. As your journey goes on, your skills will evolve, your inspiration will grow, and your perception and connection to the world around will become more attuned.

I'm so excited for you as you step into a whole new world of mindful creation!

There is something wonderful about just painting without purpose or pressure.

Materials

There are many paints, brushes, and tools available to buy for watercolor, but you really don't need much to get started. I believe that investing in a few good quality materials will make a big difference to the results you can achieve with your painting, and will also last you much longer.

PAPER

Paper is one of the most important things to invest in with watercolor. The type of paper you use will affect how the water and paint move across the paper, how the pigment settles, and how the colors blend together. Watercolor paper is available in different textures, weights, formats, and colors. The finest quality watercolor paper will be made from 100% cotton.

> *It is important that you use paper that is designed for watercolor. I recommend cold-pressed watercolor paper for beginners, at least 300gsm (140lb) in weight.*

TEXTURE

Watercolor paper comes in three different textures: hot pressed, cold pressed (or NOT, short for not hot pressed), and rough. I tend to use cold pressed paper for most of my work and this is what I recommend for beginners; it has a subtle texture and can be the easiest to work with. Hot pressed paper has a very smooth finish and is suited more to work with fine details such as realistic botanical illustration. Rough paper has more texture to it and tends to be used for looser paintings.

It is worth experimenting with each of these types as you develop your own style to find which you prefer, but cold pressed paper is a great place to start.

WEIGHT

Watercolor paper is available in a range of weights, indicating how thick the paper is. 140lb/300gsm is a good, standard weight for watercolor paper and I would recommend this as a minimum to avoid your paper buckling from the water. Anything heavier is usually unnecessary and will be more expensive. However, sometimes I buy sheets of heavier paper to use for gift tags or bookmarks so that they are more durable.

FORMAT

You can buy paper in a range of formats, from individual sheets and pads to blocks and handbound sketchbooks. Watercolor sketchbooks can be great for keeping your work together or for painting when you are out and about. Blocks of paper are glued all the way around with a small gap that allows you to remove the paper after you have finished painting.

COLOR

Most watercolor paper will have a subtle cream tint. You can also buy bright white paper, which allows your paintings to appear more vibrant because the white of the paper shows through the transparent washes of color.

SHOPPING FOR PAPER

My favorite brands of watercolor paper include Saunders Waterford, Arches, Fabriano, Langton, and Bockingford.

BRUSHES

Watercolor brushes are available in many shapes and sizes. I tend to use round brushes the most; they are one of the most common brushes used due to their versatility. The bristles are shaped into a round belly and fine tip. This allows you to achieve a range of different brush strokes by varying the pressure that you apply to the brush. With just the tip of the brush and minimal pressure, you can achieve fine lines and marks. By laying the belly of the brush flatter on the paper you will achieve much larger strokes and washes.

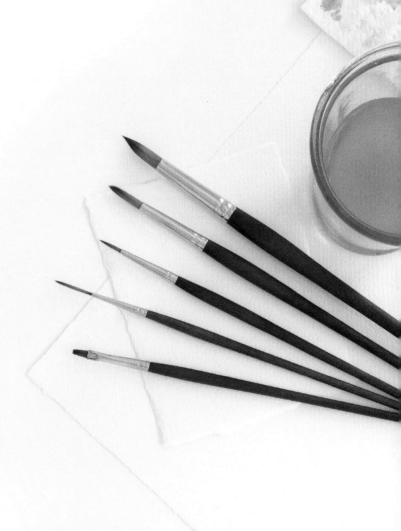

In this book, I use round brushes that are sizes 0, 2, 4, 6, 8, and 10. I also use a liner brush (size 2), which is great for painting long, thin lines and a flat shader (size 2), which is useful for painting consistent, thicker lines.

WHERE TO START

If you are completely new to watercolor, I would recommend starting with a few different sizes of round brushes like those noted above. Larger round brushes will cover a larger area of the paper, while smaller brushes are great for smaller marks and fine details, so it is useful to have a range of sizes available to you. You may find that you need to use two or three brushes in a painting to get the effects that you want. Like with the paper, I recommend investing in a handful of good quality brushes because they will make your painting process easier and retain their shape, lasting you much longer. As you get to know watercolor more and discover your own style you may find that you want to branch out into different brushes, but round brushes are an excellent and safe place to start. Most importantly, when choosing what brush to buy, make sure the brushes are specifically for watercolor because they will behave differently to other brushes.

CARING FOR YOUR BRUSHES

It is important to understand how to look after your brushes so that they will last you a long time. Never leave your brushes standing in the water because this will damage the bristles. Likewise, never store the brushes resting on their hairs. Instead, when painting always rest your brush flat on the table, and when storing always store the brush either horizontally or in a jar with the brush hairs pointing upwards. I also recommend gently cleaning them with water after each use and only using them with watercolor. Other paints like acrylics and oils or substances like masking fluid will damage the hairs of the brush.

SHOPPING FOR BRUSHES

There are many brands of brushes available. I love to use brushes from Princeton Artist Brush Company. They have a variety of series of brushes which I regularly use and would recommend, including Aqua Elite, Heritage, and Velvet Touch.

PAINT

Watercolor most commonly comes in pans (dried blocks of paint) and tubes (paste). I use both; they each have their advantages. Pans are portable, convenient, and easy to pick up for a quick painting session. Tubes are useful when you want to mix up larger quantities of paint and they can be more vibrant.

You can buy paints individually or in sets. I would recommend investing in a small palette of good quality paints to get you started, which you can add to as you get to know what colors you like. Good quality paints will contain more pigment than cheaper paints, giving you a more vibrant color, mixing better with other colors, and lasting you much longer. Popular brands like Winsor & Newton have both a student range and a professional range of watercolors for you to choose from, depending on how much you want to spend. I've used their professional range throughout this book.

CHARACTERISTICS

Each watercolor paint will have its own unique characteristics, which will determine how it behaves.

TRANSPARENCY & OPACITY
Most watercolors are transparent, which is what makes the paint so unique and appealing. They let light through, making the colors appear more vibrant. In contrast, opaque colors do not let the light through and can appear duller, but they can be useful for creating contrast and final details.

GRANULATION
Some watercolors will granulate, which will mean that the paint will appear grainy. This can be useful for adding texture to a painting.

STAINING
Staining colors will attach quickly to the paper, making them difficult to lift or remove. This is a useful characteristic to know about if you plan to lift the color for highlights as it will be harder to do so with staining colors.

LIGHTFAST
Lightfast refers to how the paint will last over time with exposure to light. Some colors will fade or change so it is good to choose colors that will last if you plan to display your painting or give it away as a gift.

SHOPPING FOR PAINT

Most manufacturers will have charts and codes on their website, detailing each color and their characteristics so I encourage you to look at these when choosing your paints. See *Choosing Your Palette* for more tips on buying your paints.

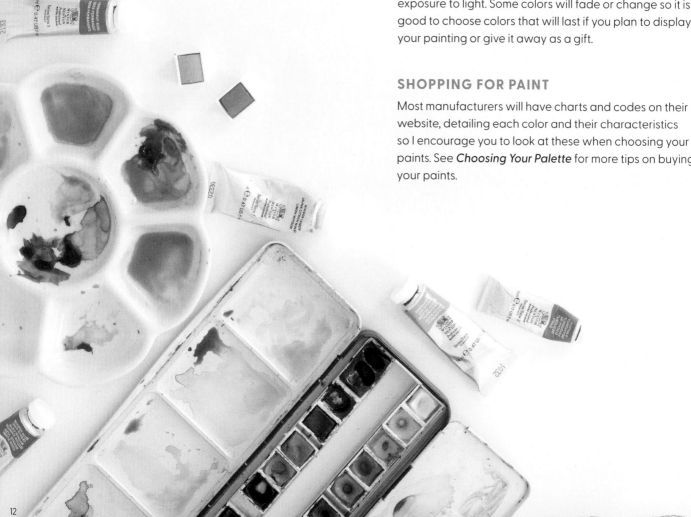

OTHER SUPPLIES

You will need a few other basic supplies to get started. Some of these are essential and some are optional extras but are things that I use regularly and would highly recommend. We will use all these items in this book. You should be able to find most of these around your home or in your local craft shop.

THE ESSENTIALS

MIXING PALETTES

Sets of pans will usually come with a built-in palette on the lid, which can be very convenient for mixing your colors on. When I am using tubes, I like to use ceramic palettes to mix the paint on; either a flat plate if I am working quite delicately without too much water, or a palette divided into compartments of wells so that I can create more watery mixes. These wells are great for larger pieces, washes, and landscapes.

WATER

You will need some water to add to the paint and to clean your brushes with when switching between colors. I like to use a clear container so that I can see when the water is dirty and needs replacing. Be aware that dirty water can affect your mixes, especially if you are mixing a more delicate color like yellow. You may wish to have two glasses of water—one that you keep clean for laying down clean water and one to wash the paint from your brush with.

PAPER TOWEL

Keep a paper towel or cloth close by to take out any excess water from your brush as you paint. When using the dry brush technique or lifting, you can gently press the paper towel around the bristles of the brush to remove moisture.

PENCIL & ERASER

Keep a pencil handy for sketching out your paintings; a medium softness like a HB is a good choice. Always draw any pencil outlines lightly because you may not be able to remove them once the paint is on top. Use a kneaded eraser to lift any excess pencil marks before you start painting. This will be gentler on the paper than a regular eraser.

I like to leave my most-used supplies out on my desk, to make it easy for me to paint whenever I have time. I keep my favorite brushes in a jar and my current watercolor sketchbook nearby. If this isn't possible for you, find a space for your supplies in a cupboard near your desk so you can get set up with minimal effort.

OPTIONAL EXTRAS

MASKING TAPE

Artist's masking tape is great for holding down the paper or for protecting borders so that you can paint with a nice clean edge. Always try out the masking tape on your paper first to check that it won't rip or damage the paper. Once your painting has dried, remove the tape from the paper slowly and carefully so it doesn't pull up the paper.

OPAQUE WHITE

I like to keep an opaque white paint, like Dr PH Martin's Bleed Proof White, in my supply kit for adding white details at the end of a painting, like highlights or stars in a night sky. I also like to use opaque white gel pens for similar effects. Head to *Techniques: Creating Highlights* for more on how to use opaque white paint.

MASKING FLUID

Masking fluid can be great for protecting certain areas of your paper from the paint. It can be useful for highlights and allowing you to paint an even spread of color around the protected area. I would recommend using silicone shaper tools for applying the masking fluid because it will damage your watercolor brushes. Head to *Techniques: Creating Highlights* for more on how to use masking fluid.

TWINE

Keeping some twine or ribbon in your supply kit is useful for adding a nice finishing touch to bookmarks or tags, especially when making gifts for friends or family.

CHOOSING YOUR PALETTE

When choosing colors for your palette, you may find that there are many options out there to choose from! I recommend starting quite simple with the basic colors and building up from there.

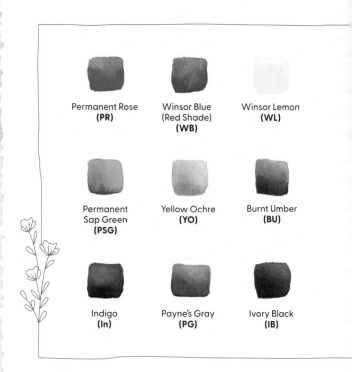

Permanent Rose
(PR)

Winsor Blue
(Red Shade)
(WB)

Winsor Lemon
(WL)

Permanent
Sap Green
(PSG)

Yellow Ochre
(YO)

Burnt Umber
(BU)

Indigo
(In)

Payne's Gray
(PG)

Ivory Black
(IB)

MY PALETTE

I like to work with a fairly small palette so that I can mix my own colors, giving me more freedom and harmony in my work. The paints that I have used in this book for all of the projects, shown above, will provide you with a good starting point for your palette and they will enable you to mix a vast variety of colors for all of your paintings.

The paints I use are from Winsor & Newton's professional watercolor range but there are lots of different brands and ranges to choose from when buying your paints. For the projects in this book, I would recommend finding colors as close to these as possible to enable you to get similar results.

CHOOSING COLORS

As a minimum, I would recommend including three primary colors (red, blue, and yellow) in your palette, which will form the basis for mixing a variety of colors. I use Permanent Rose, Winsor Blue (Red Shade), and Winsor Lemon, which are the recommended primary colors in the Winsor & Newton professional range. It can be useful to have a pre-mixed green like Permanent Sap Green in your palette, as the foundation for mixing a variety of warm and cool greens for foliage. Yellow Ochre is a lovely warm, golden yellow which can be used on its own or added to a mix for a muted green for more realistic looking leaves. For a brown, I like to use Burnt Umber and tend to mix it with a little blue to make it darker. It can be useful to have an opaque color in your palette like Indigo, which is a beautiful, deep blue that is a great cool alternative to black for final details. Similarly, Payne's Gray is a semi-opaque dark, blue-gray that is also great for adding contrast. I also like to keep the Ivory Black in my palette for convenience, although you can mix up your own black quite easily using the three primary colors.

BUYING A SET

Most sets of paints will come with a range of colors that include three primary colors. They may contain a warm and cool variety of each color, which is important to be aware of as these will affect your mixes (see *Warm and Cool Colors*). Sets usually include a pre-mixed black and white as well. The white is usually the one paint that will remain untouched in most artists' palettes due to its transparency. Instead, I always like to keep an opaque white in my supply kit (see *Materials: Other Supplies*).

WARM AND COOL COLORS

When shopping for paints, you will find that there are many different versions of each color. For example, there will be lots of different blues to choose from. While blue is generally categorized as a "cool" color, compared to red, that is a "warm" color, every color can have a warm and cool version, relative to the other colors next to it on the color wheel. Some blues may have a red undertone, making it feel warmer, and some may have a yellow undertone, making it feel cooler. This undertone can affect the overall mood of your painting and can also affect your results when mixing. We will cover this more when we look at mixing complementary colors in *Mixing Colors*. In Winsor & Newton professional range, there is a Winsor Blue (Red Shade) and Winsor Blue (Green Shade). The red shade is the one that is recommended as a primary blue, best for mixing a variety of colors, and is the one I have used in this book.

Check with the manufacturer of your paints to see which primary colors they recommend for mixing; these will differ across brands and ranges. For the Winsor & Newton Cotman Range (a smaller, less expensive range) the three recommended primary colors are Lemon Yellow Hue, Ultramarine, and Permanent Rose.

Watercolor Basics

Learning something new can be quite daunting, especially when there are so many unfamiliar words and processes to get your head around. I hope the next few pages will help you to understand the basics of watercolor and build your confidence as you begin to establish an enjoyable art practice.

COMMON TERMINOLOGY: A QUICK GUIDE

BACK-RUN (ALSO KNOWN AS BLOOMS):
Cauliflower-shaped marks that are created when excess moisture runs back into a dry or drier area of paint.

BLEEDING:
When the paint moves across the wet paper, creating a soft edge or back-run.

BLENDING:
Creating a transition by either blending colors together or blending one color from dark to light.

BUCKLING:
The expansion, bending and wrinkling of paper caused by excess water.

CONCENTRATED:
A strong mix of color that contains a lot of paint and a little water.

DAMP BRUSH:
A brush that is moist but does not drip and will not release much water when applied to the paper. In this state, it will be able to help move paint around on the paper just using the existing water on the page.

DILUTED:
A pale mix of color that contains a lot of water and a little paint.

DRY BRUSH:
A brush that is almost dry but still able to hold paint. In this state, it will be able to absorb water from the paper via the method of lifting.

DRY BRUSHING:
A method of applying paint to paper, when dry paint is applied to dry paper.

FLAT WASH:
An area of evenly distributed color.

GRADIENT OR GRADUATED WASH:
A wash of color that gradually transitions from light to dark.

LAYERING:
Building up layers of paint on top of each other, increasing in darkness.

LIFTING:
Using your brush to pick up paint or water from the paper, to either remove excess, fix a mistake, or create a highlight.

MIX:
The combination of paint and water on your palette, whether it is one color or multiple colors mixed.

NEGATIVE PAINTING:
When an area is painted around, giving form to the unpainted space within.

MUTED:
A color that is made up of all three primary colors and is desaturated to some degree. This may be a pure color that has had a complementary color added to it to take away its vibrancy.

OPAQUE:
Opaque watercolors do not allow the light to pass through the pigment and often appear duller than transparent watercolors.

PALETTE:
This refers to both the range of colors in your supply kit and the surface that you mix your colors on.

PIGMENT:
Pigment gives the watercolor its color. Higher quality paints contain more pigment, meaning they last longer, mix better and are more vibrant.

PURE:
A pure color refers to colors that are made up of only one or two primary colors.

TRANSPARENT:
Transparent watercolors allow light to pass through the pigment letting the white of the paper show through underneath, creating a glow.

WET-ON-DRY:
A common method of applying paint to paper, when wet paint is applied to dry paper.

WET-ON-WET:
A common method of applying paint to paper, when wet paint is applied to wet paper.

VARIEGATED WASH:
A wash of color that gradually transitions into another color.

VALUE:
The strength of a color, varying from light to dark, made by using more or less water.

GETTING STARTED

Now that you have your supplies and you're ready to go, you may be wondering how to get started. Here are some basic tips to get you into good habits for holding the brush and preparing the paint.

HOLDING THE BRUSH

Hold the brush in a firm but relaxed grip between your thumb and forefinger, close to the where the handle meets the ferule (the metal part) to allow yourself a good range of movement **(a)**. For finer details, try moving your grip slightly more towards the brush hairs for more control. For larger, looser brush strokes hold it a bit further away from the brush hairs to increase your range of movement.

As you start to paint, you can gently rest your little finger on the table for stability. While you are painting, think about changing the angle of your hand so that you can pull the brush along the paper in different directions, finding what feels comfortable for you with each brush stroke.

PREPARING THE PAINT

TUBES:

Gently squeeze a small amount of paint out of the tube at the edge of your palette. Put the lid back on so that the paint in the tube doesn't dry out. Swirl your brush around in the water so that the bristles are fully wet. Add the water from the brush to the palette next to the paint and then gently pull some of the paint into the water **(b)**. Mix the water and paint in a circular motion until it is all mixed in. Roll the brush around in the paint to ensure the bristles are fully coated and then apply the paint to the paper.

PANS:

Add a drop of water on top of your chosen pan for a few seconds to activate the dried paint. Then brush back and forth to pick up the paint, being careful not to jab the pan with the tip of the brush as this may damage the hairs **(c)**. Coat your brush with the paint and move it to your palette to mix, or add it straight to your paper.

When you are painting larger areas like background washes, it is useful to prepare your paint in a palette with a well **(d)**. This will allow you to mix a larger volume of color. Add your paint into the well and then keep adding water until you have the desired amount.

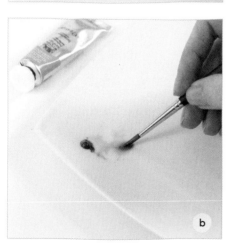

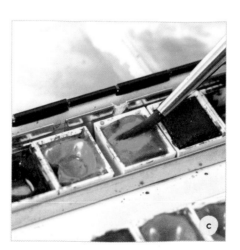

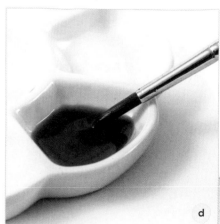

WATER CONTROL

Understanding how the water affects your paint is fundamental to understanding watercolor. It is the amount of water you use that will determine how the paint moves and how it settles on the page. Think of the water as carrying the paint across the page, allowing the paint to run and bleed into the wet surface. The paint will continue to move until the water has dried.

HOW MUCH WATER

The amount of water you need to use will vary depending on the effect you want to achieve. For finer details you will only need a small amount of water, just enough to activate the paint. This will allow you to have more control and a more precise brush stroke. For larger or looser areas with soft bleeds of paint you will need more water, which will allow you to spread the paint further and will allow the paints to mix together on the paper. Generally, more water equals more movement of the paint, less control, and more diluted colors.

TOO LITTLE

If you have too little water in your brush, the paint will become patchy when you add it to the paper. You will not be able to spread it or blend it with other colors **(a)**.

TOO MUCH

If you use too much water, you will have a puddle on the page making the result very washy and lacklustre and it will potentially buckle the paper **(b)**. The paint will float on top and as it dries the water will push it to the edge of the wet area, resulting in a hard line around the edge. Having excess water like this can also take a really long time to dry.

JUST RIGHT

Generally, you want the brush to be saturated with paint and/or water, but not dripping. This will allow you to achieve a balance between the two extremes described above **(c)**.

The best way to understand how much water to use is to simply paint, observe, and experiment! It is well worth spending the time getting to know watercolor by practicing the basic techniques. This can be really fun and relaxing in itself, exploring how the paint reacts with more or less water. And remember, the more you paint, the more these techniques will become second nature.

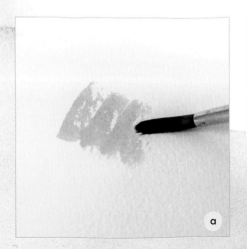

a

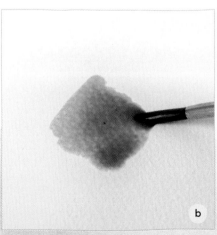

b

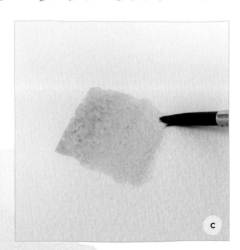

c

REMOVING EXCESS WATER

As you paint, you will constantly need to adjust the amount of water you are using, depending on what you are painting. There are a number of ways you can remove excess water from your brush and paper.

FROM YOUR BRUSH

To remove excess water from the brush, you can either gently press the brush against the side of your water jar to push out the water **(d)**, press it onto your palette, or dab it gently onto your paper towel **(e)**.

FROM YOUR PAPER

To remove excess water from the paper, you can lift it off with a dry or damp brush. Gently hold the brush to the excess water on the paper so that it will absorb it **(f)**. Dab the brush onto your paper towel to take out the water and then repeat if necessary. It can be helpful to tilt the page to see how much excess water you have, so that the water runs to the bottom. You can then lift this with your brush **(g)**.

BE CONSCIOUS OF THE DRYING STAGES

Adding more water to paint that has already started to dry on the paper can create back-runs and easily ruin your work **(h)**. The new water will reactivate the drying paint, picking it up and carrying it outwards. Once it dries, there will be a paler patch where the new water was applied surrounded by a hard line of paint. We usually want to try and avoid this, so always be careful of going back to your painting as it dries.

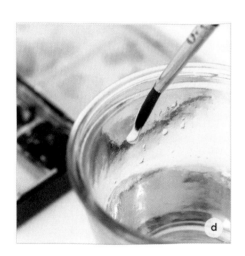

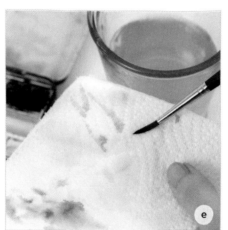

You can also use a paper towel to lift excess water from the paper. Gently press a folded corner of the paper towel to the water to absorb it. Be careful not to press too hard otherwise it will lift the color.

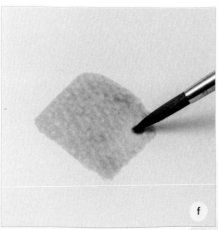

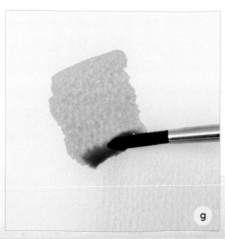

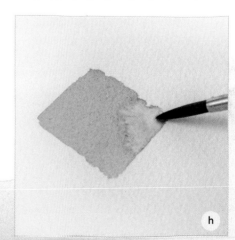

Mixing Colors

Knowing how to mix your colors will give you so much freedom and potential with your paints and will allow you to achieve more harmony in your art. Experimenting with mixes can be really fun and I hope this section will help build your confidence for using a limited palette.

VALUES

Values are the range of tones that you can mix with each color, from light to dark. With watercolor, you can achieve this range by either adding more water to dilute the mix, making the color lighter, or by using less water and more paint to make the color more concentrated and darker.

ADDING DEPTH AND DIMENSION

Understanding how to use a range of values in your paintings will allow you to transform your piece from something that may look quite flat and two-dimensional to something that has much more depth and dimension. You will be able to show highlights and shadows so that you can illustrate forms **(a)**. You will also be able to create the perception of distance, with lighter areas appearing farther away and darker areas appearing closer in scenes and landscapes **(b)**.

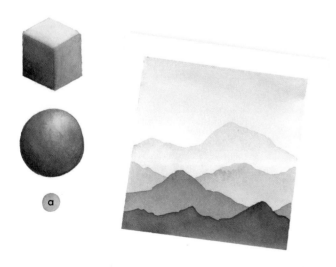

(a)

(b)

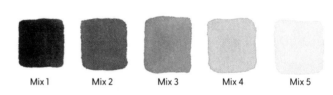

EXERCISE: MIXING VALUES

Mix 1 Mix 2 Mix 3 Mix 4 Mix 5

Start by adding one of your paints to the palette.

- **Mix 1:** For the first mix, use very little water—just enough to activate the paint. Coat your brush with the paint and add it to the page. By using only a small amount of water, the pigment will be at its darkest value. These dark values are great for adding final details to your work and to create depth and contrast.

- **Mix 2:** Next, add slightly more water to dilute the paint on your palette. You won't need to add too much to reduce the strength of the color. Apply it to the page and it should be paler than the previous swatch.

- **Mixes 3, 4 and 5:** Repeat this process, adding a little more water and applying the paint to the page to see how the color gradually gets lighter. Do this until the color is so pale that it is barely visible. These palest mixes are really useful to practice and are great for adding subtle colors to your piece or for background washes.

THE COLOR WHEEL

Understanding the basics of color theory will help you to mix a beautiful variety of colors for your paintings. This starts with understanding the color wheel. The color wheel is made up of three primary colors that cannot be mixed from other colors: red, blue, and yellow.

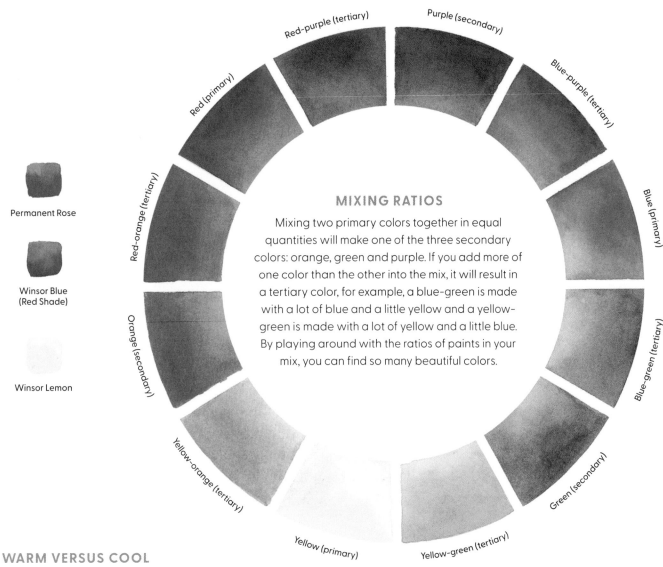

Permanent Rose

Winsor Blue (Red Shade)

Winsor Lemon

MIXING RATIOS

Mixing two primary colors together in equal quantities will make one of the three secondary colors: orange, green and purple. If you add more of one color than the other into the mix, it will result in a tertiary color, for example, a blue-green is made with a lot of blue and a little yellow and a yellow-green is made with a lot of yellow and a little blue. By playing around with the ratios of paints in your mix, you can find so many beautiful colors.

WARM VERSUS COOL

Warm colors (red, orange, and yellow) sit on one side of the color wheel and cool colors (purple, blue, and green) sit on the other side. However, it is important to remember when choosing your paints, as we discussed in *Materials: Choosing Your Palette*, that there are warm and cool varieties of each color and these will affect your mixes.

MAKE YOUR OWN COLOR WHEEL

A color wheel can be a useful guide when mixing. Simply draw a large circle and then map out 12 sections evenly spaced around the edge. Using the wheel above as a guide, start by painting in your pure primary colors, then mix and add in your secondary and tertiary colors in between.

EXERCISE: MIXING PRIMARY COLORS

Choose two primary colors to mix. Always start with the color that you want to be most dominant in the mix, adding it to your palette first. Place the second color next to the first on the palette and then gradually add it in, mixing for a few seconds until the colors are fully combined. You will not need much color to affect the mix, so add any new color slowly. Paint swatches on your paper to show the variety of colors you can achieve as you gradually add more of the second color.

(a) Permanent Rose + Winsor Blue (Red Shade): Start with Permanent Rose, gradually adding in Winsor Blue (Red Shade). With this mix you will achieve a range of pink-purples, purples, and blue-purples until you return to the pure Winsor Blue.

(b) Permanent Rose + Winsor Lemon: Start with Permanent Rose again, this time gradually adding in Winsor Lemon. With this mix you will be able to achieve red-oranges, oranges, and yellow-oranges until you return to the pure Winsor Lemon.

(c) Winsor Blue (Red Shade) + Winsor Lemon: Start with Winsor Blue (Red Shade) and gradually add in Winsor Lemon. With this mix you will be able to achieve blue-greens, greens, and yellow-greens before you return to the pure Winsor Lemon.

> *When practicing mixing and making swatches of your colors, remember to label them so you don't forget how they were made. This will be useful to refer back to later so you can make the same color again.*

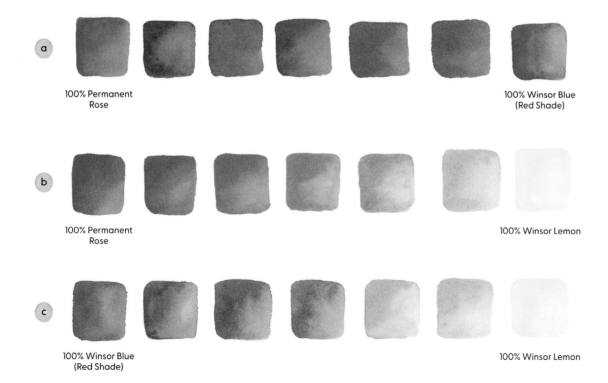

a 100% Permanent Rose 100% Winsor Blue (Red Shade)

b 100% Permanent Rose 100% Winsor Lemon

c 100% Winsor Blue (Red Shade) 100% Winsor Lemon

MUTED COLORS

Muted colors are colors that have less vibrancy. These colors can be more relaxing and also more realistic than purer colors. You can make muted colors by adding a complementary color into the mix. Complementary colors sit opposite each other on the color wheel, like red and green or blue and orange. When mixing these, the key is to add a very small amount of the complementary color into the mix slowly until you get your desired color. You will probably need less than you think. Add too much and it will overpower the base color, turning it gray or muddy!

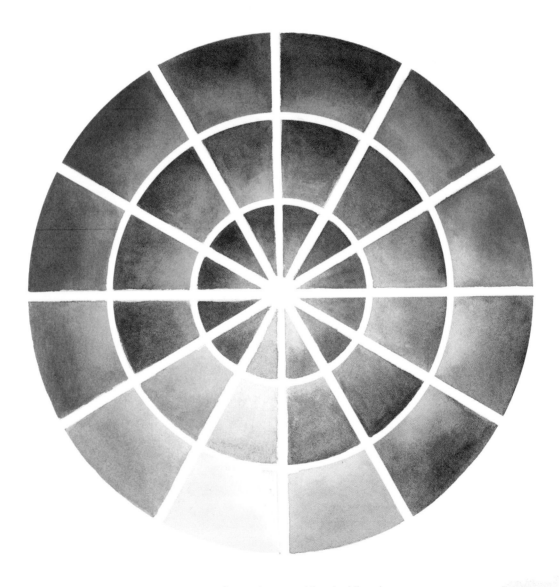

As you move closer to the center of the wheel, the colors are mixed with increasing amounts of their complementary color — you can see how they get darker and less vibrant.

EXERCISE: MIXING COMPLEMENTARY COLORS

Try making these three mixes, which we use regularly in the projects in this book. Paint swatches as you go along so you can see the color changing and notice when you have gone too far when the color has become overpowered by the complementary color or is muddy. For each of these, the first color shown is the pure color, the second color has a little of the complementary color mixed in, and the third color has too much.

(a) Muted Green: Prepare Permanent Sap Green on your palette for the base color. Add a small amount of Permanent Rose to the mix.

(b) Dusky Pink: Prepare Permanent Rose on your palette for the base color. Add a small amount of Permanent Sap Green to the mix.

(c) Dark Brown: Prepare Burnt Umber on your palette. As the main color within brown is orange, it has the same complementary color (blue), so this is what we need to add to brown to make it darker. Add a small amount of Indigo to the brown. Indigo is a very strong color so be careful not to add too much

EXERCISE: MIXING GRAYS

(d) I prefer to mix my own grays, rather than diluting a pre-mixed black as this can tend to look quite dull. By mixing your own you can add warm or cool tones, depending on what your painting needs. Practice mixing a variety of different grays using your three primary colors. Start by mixing your red and blue together to make purple and then add your yellow. To make a cooler gray, add a little more blue. To make a warmer gray, add a little more red.

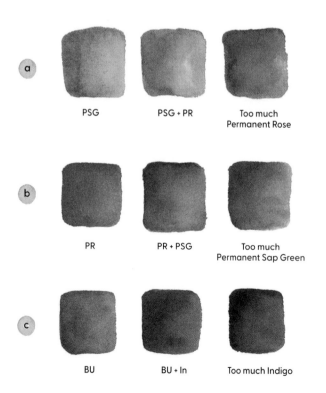

a

| PSG | PSG + PR | Too much Permanent Rose |

b

| PR | PR + PSG | Too much Permanent Sap Green |

c

| BU | BU + In | Too much Indigo |

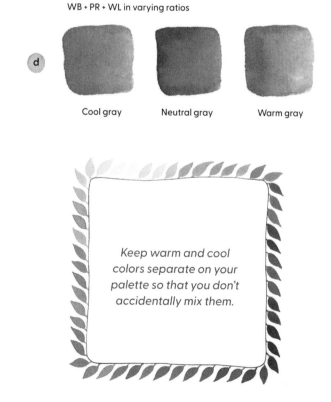

WB + PR + WL in varying ratios

d

| Cool gray | Neutral gray | Warm gray |

Keep warm and cool colors separate on your palette so that you don't accidentally mix them.

COLOR PALETTES

Color can be incredibly powerful and can have a great impact on how we feel. Warm colors (like reds, orange, and yellows) can be very stimulating, exciting, and joyful. In contrast, cool colors (like blues, purples, and greens) can be calmer, more peaceful, and sometimes even melancholic.

Warm colors

Cool colors

HARMONIOUS COLOR PALETTES

Choosing a variety of colors that work well together will create a beautiful harmony in your painting. Monochrome and analogous palettes are the simplest and most relaxing due to there being little contrast between the colors, making them pleasing to the eye and comforting to look at.

MONOCHROME PALETTE

A monochrome color palette includes variations of one color. The easiest way to do this with watercolor is to adjust the values of the color, making the color lighter or darker.

TRIADIC PALETTE

A triadic color scheme has three colors, evenly spaced on the color wheel, for example, red, blue, and yellow or orange, green, and purple. This can be a little more stimulating to the eye due to the contrast of colors, but if you soften them by diluting them or adding a complementary color, you can create some beautiful, relaxing combinations. It is common to make one of the colors in this palette the focal color in your painting, with the remaining two less prominent.

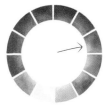 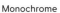 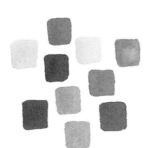

Monochrome

 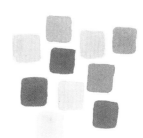

Triadic

ANALOGOUS PALETTE

An analogous palette includes colors that sit next to each other on the color wheel, sharing similarities, like blues and greens, or pinks and purples. You will notice it a lot in the patterns, borders, and projects within this book.

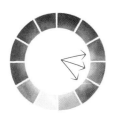 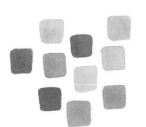

Analogous

When choosing a relaxing color palette, I like to go for cooler colors like greens and blues because I find them the most calming. However, by diluting or muting warmer colors with water or a complementary color, you can make more beautiful, calming colors.

Techniques

In this chapter, we will cover a range of watercolor techniques, from brush strokes to methods of applying paint and how to create washes, highlights, and splatters. Taking the time to practice and understand these techniques will not only build your confidence, but will also allow you to create a variety of wonderful watercolor effects!

Brush Strokes

Practicing these simple exercises regularly will help you to become more familiar and confident with your brush. I have used a size 4 and size 6 round brush for all of these exercises. I would recommend practicing with a variety of sizes so you know which brush to pick up for which stroke you want when you are in the middle of a painting.

Lines are great for practicing details, edges, or the stems of flowers and leaves. You may find it helpful to turn your paper at a slight angle on the desk when painting these. This means that your elbow is held slightly away from your body, giving your arm more space to move. We'll also look at some organic marks that work well for fine details and creating textures. Don't rush these exercises; go nice and slow.

EXERCISE: LINES

1a Pick up your paint and remove the excess water (see *Watercolor Basics: Water Control*). Hold the brush at about a 45 degree angle from the desk and using just the tip pull the brush across the paper painting a fine line. Focus on moving your whole arm instead of just your wrist to give you a good range of motion.

1b Now repeat Step 1a, but this time paint a thicker line by applying more pressure to the brush so it lays flatter on the paper.

1c Practice painting lines in different directions, moving the paper on the desk so that you are always working at a comfortable angle.

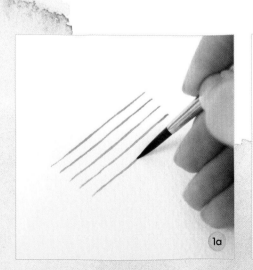

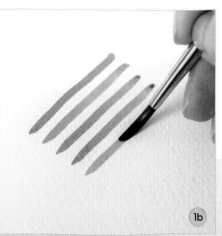

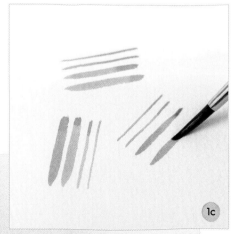

EXERCISE: WAVY LINES, VARYING PRESSURE, AND FLICKING LINES

2a Now practice some curves and wavy lines. Try to keep the width of the brush stroke as consistent as you can all the way along.

2b Going back to a straight line now, vary the pressure of your brush, starting with a thin stroke and gradually increasing and then releasing the pressure. Alternate between these two motions without lifting your brush from the paper. We'll practice this more later in the book when painting leaves (see *The Projects: Leaves*).

2c For flicking lines, press the brush down and then use a quick motion to drag and lift the brush, creating a tapered brush stroke. These brush strokes are useful for painting grass.

EXERCISE: MARKS AND FINE DETAILS

3a Organic marks, dots, and dashes work well for fine details or creating texture. For these marks, press down with your brush, then quickly lift it up. Repeat this, varying the pressure, and see how it varies the size of the mark you make. These marks can be great for suggesting leaves on trees.

3b Now practice more delicate dots and dashes using just the tip of the brush. These fine details will help to give the finishing touches to flowers.

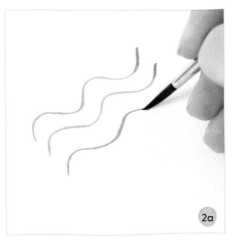

2a

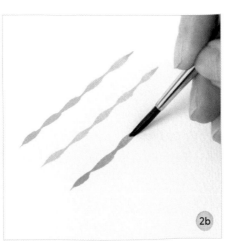

2b

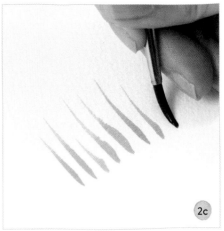

2c

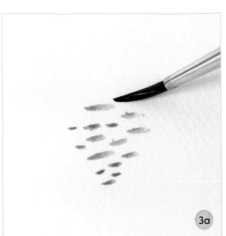

3a

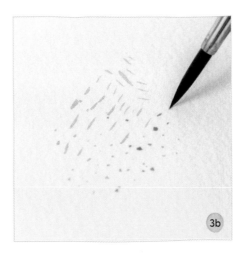

3b

When painting more delicate details, always take out the excess water and keep your paper towel handy. A drier brush allows more control and produces finer marks.

Painting Shapes

In any subject you paint, you will find a variety of shapes, so it is well worth practising painting some of the most common ones in order to create good forms and neat edges. Just like the simple brush strokes, repetitive shapes are also wonderful to paint on their own for relaxation and you can turn them into bookmarks, cards and gift tags. Head to *The Projects: Layered shapes* and *More inspiration: Patterns* to see some examples.

EXERCISE: PRE-DRAWN SHAPES AND EDGES

It is helpful to practice filling in different outlines so that you can paint neat edges within a pre-determined shape.

1a Start by drawing a square in pencil. Add the paint into the center of the square in a few short back-and-forth strokes.

1b Slow down as you pull the paint out to the edges.

1c Change the direction of the brush as you need to for more control.

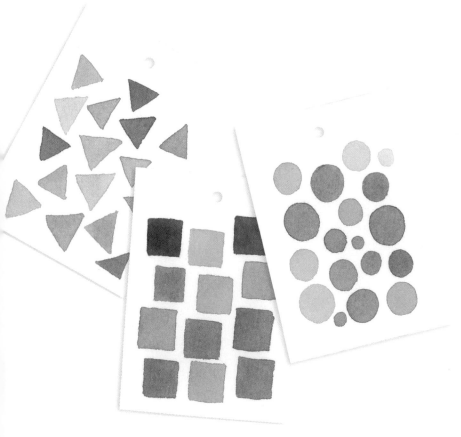

As I paint shapes and edges, I constantly change the direction of my brush so that the tip of the brush is either pointing toward the edge or the brush is parallel with the edge. This gives me more control and a clean edge.

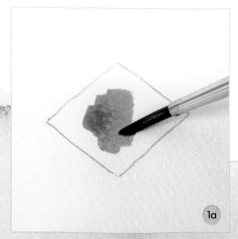

1a

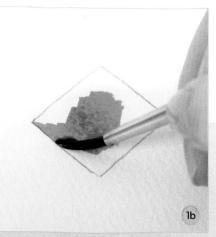

1b

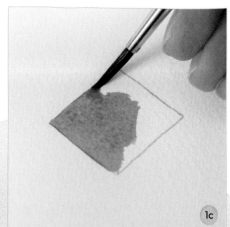

1c

EXERCISE: FREEHAND SHAPES AND EDGES

2a Painting freehand squares: I usually start with the outline first. Paint four lines, lifting the brush from the paper and changing the direction for each edge.

2b While the outline is still wet, fill in the center of the square.

2c To sharpen up the corners, remove any water from your brush and use the tip of the brush to move the existing paint on the page to a sharp point.

3a Painting freehand circles: Paint the outer edge first in a single stroke. Adjust the edge as you need to, to make it rounder—don't worry if you don't get it right on the first attempt!

3b Then fill in the center. If water starts pooling in your shape, make sure you lift it up to avoid a back-run.

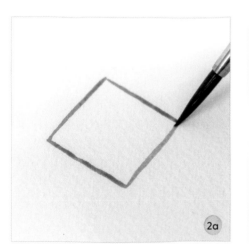

2a

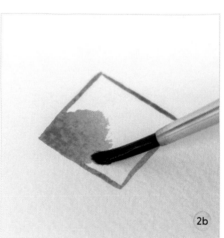

2b

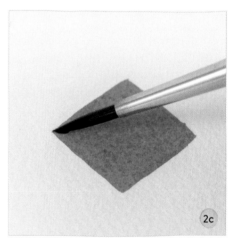

2c

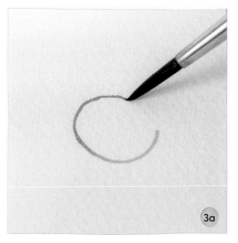

3a

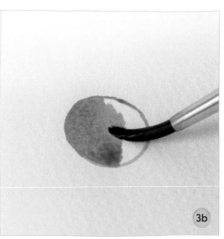

3b

Continue practicing with more shapes like triangles, ovals, stars, and hearts. You can also make up your own organic shapes that are less regular in form.

Methods of Applying Paint

There are three main methods for applying watercolor paint to the paper, giving you a range of effects that you can create with your painting. These are wet-on-dry, dry brushing, and wet-on-wet. In most of the projects in this book we will use a combination of wet-on-dry and wet-on-wet to create a lovely contrast: wet-on-wet for the soft background layers and wet-on-dry for the final crisp details. Dry brushing is used less frequently but is a very useful method for adding texture to your work.

WET-ON-DRY (WOD)

Wet-on-dry is when you apply wet paint onto dry paper. With this method you have the most amount of control be ause the paint will only go where you place it with the brush. You will be able to achieve crisp, clean edges so it is great for adding details or for paintings that require precise edges or marks.

LAYERING

Layering is when you build up layers of paint, starting with the lightest washes, ending with the darkest details. Wait until each layer is completely dry before adding the next.

DRY BRUSHING

Dry brushing is when you apply dry paint to dry paper. With this method, you can achieve a really lovely patchy, textured effect that is great for things like scattered leaves or the texture in subjects like wood. It works best on cold pressed paper or rough paper where the paint can touch the bumps of the paper, skipping over the dips.

EXERCISE: PAINTING WITH A DRY BRUSH

2 Pick up your paint and then remove the moisture from your brush with your paper towel, gently squeezing if necessary. The color should remain in the brush. Using the side of your brush, spread the paint across the page. You can then build up the layers with darker colors. This method can take a bit of practice and it's useful to check how dry your brush is on a scrap piece of paper before applying it to your work.

EXERCISE: PAINTING WET-ON-DRY

1a Paint a large square with a diluted mix and leave to dry completely.

1b Paint a smaller square over the top, with a slightly more concentrated mix.

1c Once dry, paint a third, smaller square over the top in a much more concentrated mix.

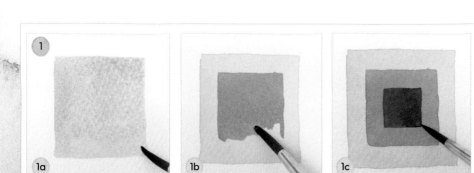

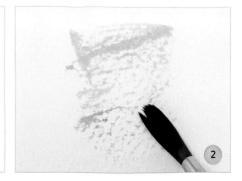

WET-ON-WET (WOW)

Wet-on-wet is when you apply wet paint to wet paper. This method is great for creating beautifully soft blends and edges as the paint bleeds into the wet surface. You can apply paint to either a clean wash of water that you have laid down or on top of another color (that is still wet) that you want to make darker or blend with. Bear in mind, how wet the paper is will determine how the paint reacts and spreads. The wetter the paper is, the more the paint will spread. If it is too dry, it will not spread very much.

It is important to work quite quickly with wet-on-wet, preparing your mixes before you start so that the first layer of water or paint doesn't start drying before you apply the second. When painting with this technique, be aware that the paint will keep moving until it is completely dry so the end result may look quite different to when it was wet.

When adding paint to a wet surface, the additional water on the page will dilute the color further, so if you want a darker or more vibrant result, make sure to use a more concentrated mix of paint.

EXERCISE: PAINTING WET-ON-WET

3 **On wet paper:** Using a clean wet brush, paint a square of water. While the water is still wet, drop in some paint and watch it spread. Paint some horizontal strokes as well. Try this exercise with varying amounts of water to see how the paint behaves.

4 **From dry to wet paper:** For crisp edges, draw a square then paint the first layer of water slightly inside the edges. Then use the tip of your brush to paint the outer edge onto the dry paper just within the edges. As the paint touches the wet area on the inside, it will bleed in.

5a **Between adjoining shapes:** First, paint a circle with a concentrated mix of paint. Now wash the paint from your brush, removing the excess water, and paint another circle next to the first, just slightly overlapping. The paint from the first circle should bleed into the second.

5b Paint another more concentrated circle next to this one. Keep going, painting circles in a single line or in rows. This is a fun technique that can be a relaxing exercise to do on its own, watching how the paint moves. See *More Inspiration: Patterns* for an example of where I have used this technique in a gift tag.

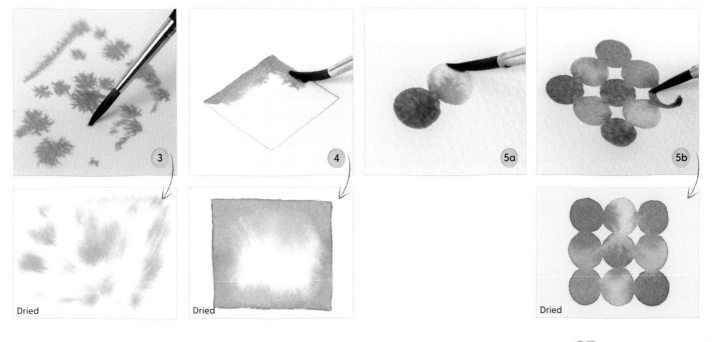

3

4

5a

5b

Dried

Dried

Dried

Washes

Washes are areas of color that are painted with overlapping brush strokes to achieve a seamless finish. These are usually the first layers that you paint within a painting before you start building up the details. You can paint flat washes, graduated washes and variegated washes.

FLAT WASHES

A flat wash is an area of evenly distributed color. You will need to work fairly quickly with a consistent amount of water to produce an even coverage.

EXERCISE: SMALL AREA

1 Load your brush with paint and apply to the paper with a back and forth stroke, laying your brush flat to the paper to achieve maximum coverage. Move down the paper, slightly overlapping the previous strokes of paint. Repeat this process until the area is covered. Try to avoid going back over any of the existing paint because this may disturb it as it dries. If you find that you have any water pooling at the edges, dry your brush and gently lift this out to avoid any back-runs as the paint dries.

EXERCISE: LARGER AREA

2a First, apply masking tape around the edge of the area you are painting if you want a clean edge. Then prepare enough paint for the area you want to cover (see *Watercolor Basics: Preparing the Paint*). Tilt your paper to encourage an even flow of paint, by either holding it or leaning it against something. Start at the top, painting horizontal strokes. With the paper tilted, a bead of water should form at the bottom edge of the paint.

2b Load your brush with paint again and then return to the painting, continuing with these horizontal brush strokes just over the bead line, pulling the water down. When picking up more paint, try to avoid dipping your brush into the water because this will dilute the paint. When painting, try to avoid disturbing the paint that you have already painted as this may create patches.

Keep going until you reach the bottom. If you still have a bead of water left at the bottom, dry your brush and gently lift it up.

> *You can apply washes to either dry paper or wet paper. Wetting the paper first can allow the paint to blend more easily and may produce a smoother transition.*

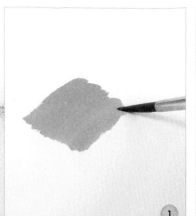

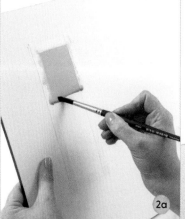

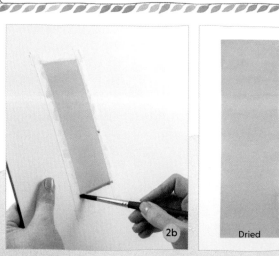

1 2a 2b Dried

GRADUATED WASHES

A graduated wash is when one color transitions smoothly from dark to light. We can use this technique to create dimension in our subjects, for example for subjects with cylindrical shapes like tree trunks or plant pots. With these, we want the edges to be darker so that it gives the illusion that the shape is curved. We can also use this type of wash for painting skies, which naturally get lighter as they get closer to the horizon.

4a For a larger area, tilt the paper just as we did for the flat wash. However, instead of returning to the palette so that the color remains consistent throughout the wash, this time we will add more water as we go along so that the paint becomes more diluted and paler. Start with a concentrated mix at the top so that there is enough contrast in the transition.

4b Wash the paint from your brush and continue pulling the bead of water down. Repeat this until you get to the bottom and then remove any remaining water that is pooling.

EXERCISE: SMALL AREA

3 Paint a thick line of paint, then wash the paint from your brush. Take out the excess water then run the brush along the edge of the paint, softening the edge and creating a subtle gradient. Avoid using too much water because this will cause a back run, pushing the paint back in the opposite direction. Add more paint to the darker side if you need more of a contrast.

Try this graduated wash with the wet-on-wet technique, covering the area with clean water then adding plenty of paint at the top, pulling it down in horizontal strokes. The color will naturally fade out as you move further down the paper.

3

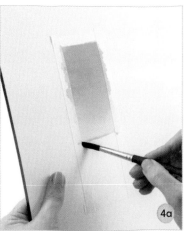

4a

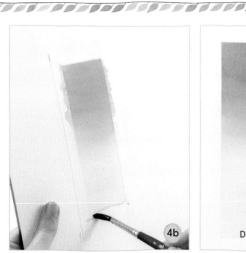

4b

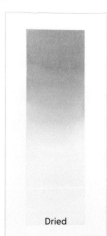

Dried

VARIEGATED WASHES

A variegated wash is when you create a smooth transition from one color to another. These washes tend to work best when using colors that sit next to each other on the color wheel. Yellows, oranges, and reds can make a lovely sunset, which we will be painting in one of the projects (see *The Projects*: *Reeds At Sunset*).

EXERCISE: SMALL AREA

5 Paint a small area of yellow onto your paper. While still wet, add orange using consistent back and forth strokes to overlap the yellow, leaving some of the yellow visible. To blend in the colors more, use a damp brush to run all the way through the paint with consistent back and forth strokes. Stop before it starts to dry.

EXERCISE: LARGE AREA

For larger areas, I find the easiest way to paint a variegated wash is using the wet-on-wet technique. Prepare your mixes first and then add clean water to the paper. Tilt the page so any excess water runs to the bottom and lift with your brush or paper towel.

6a Laying the paper down flat gain, add yellow to three-quarters of the paper. Next add orange about half way down the yellow using horizontal strokes for an even spread, leaving a gap at the bottom for the red.

6b Finally, add in the red at the bottom, overlapping some of the orange so that it blends in, using horizontal strokes. To blend in more, you can turn your paper so that the red is at the top and then run your brush back and forth consistently down the whole piece while it is still wet.

You can also try this using the wet-on-dry technique, just like we have with the other washes, tilting the paper to form a bead of water at the bottom of the paint. This time, mix the paint on your palette as you go so the color gradually changes as you move down the page.

> *Make sure you're using the right size brush for the size of the area you want to cover. For the larger wash I used a size 8 round brush. Using a brush that is too small for the area you are trying to cover may result in streaks throughout your painting.*

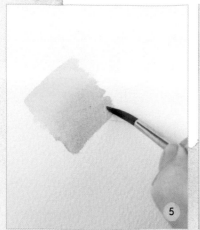
5

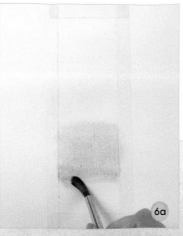
6a

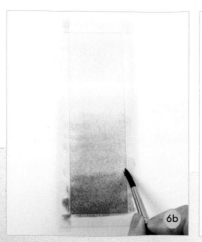
6b

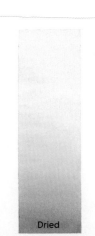
Dried

Creating Highlights

There are a few different ways to create highlights in your paintings. All of these are useful to know and will be valuable for different reasons. Highlights are lighter areas that are reflecting a light source and they can provide more interest, dimension and realism to your paintings.

EXERCISE: PAINTING AROUND THE HIGHLIGHT

One of the most common ways to create a highlight is to paint around the area, leaving the white of the paper, or a lighter color, shining through. This gives you a good level of control but can be quite time consuming.

1 Paint a circle, leaving a white curve in the top right corner to suggest where the light could be hitting it. Try to keep the curve almost parallel to the edge of the circle. We will create highlights like this in some of the projects, including the avocado, jellyfish, and pebbles.

EXERCISE: LIFTING

Lifting is a very useful method for removing paint from the paper to create highlights or to fix mistakes. Be aware that some colors will lift easier than others due to their staining properties and you may not be able to lift enough paint so that the paper completely returns to white.

2 **With a brush:** Paint a swatch of color. Clean your brush and remove the water from it by gently squeezing the hairs with your paper towel. While the paint is still wet, press the brush down and drag to lift up some of the paint. There will now be paint on your brush, so if you need to lift more, you will need to clean and dry your brush again first. You may need to repeat this a few times to remove a sufficient amount of the paint. Using a brush with harder bristles will result in a more distinct edge.

3 **With a paper towel:** You can also use your paper towel to lift up paint for highlights or for clouds in a sky. Paint a large square with light blue paint. Fold your paper towel and dab it onto the paper to lift some of the paint to form clouds shapes.

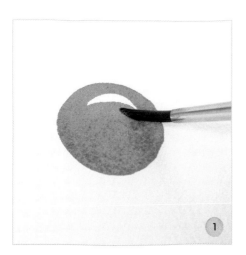

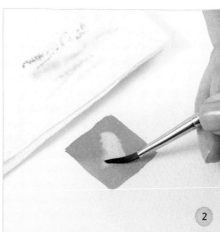

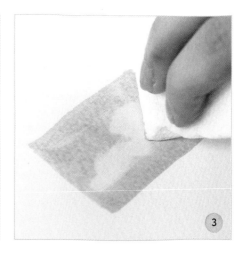

EXERCISE: MASKING FLUID

Using masking fluid allows you to protect white areas of paper to create highlights. This is a particularly useful method if there are a lot of small highlights that would otherwise take a long time to paint around. It also allows you to paint a consistent smooth wash over the top of the protected area.

4a Using a silicone shaper tool or an old brush, apply the masking fluid to the paper in the areas that you want to protect.

4b Wait for the masking fluid to dry completely before painting over the top.

4c Once the paint has dried, gently rub the masking fluid with your finger or an eraser to remove it, revealing the white paper underneath. Be careful not to pull at it too much otherwise it may cause a tear in the paper.

EXERCISE: OPAQUE WHITE PEN OR PAINT

Using opaque white allows you to add the highlights at the end when your painting is finished and has dried. It is also really useful for winter scenes when adding snow to your painting.

5 **With a pen:** Paint a flat wash of concentrated paint and then leave to dry. Use your white pen to add some marks and patterns over the top.

6 **With paint:** Paint a flat wash and leave to dry as before. Add a little water to your white paint and paint some marks on top of your wash.

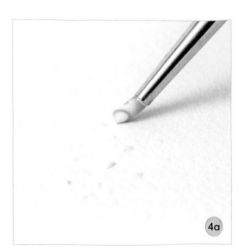
4a

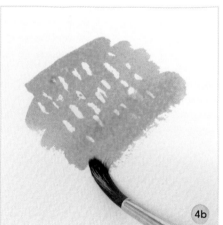
4b

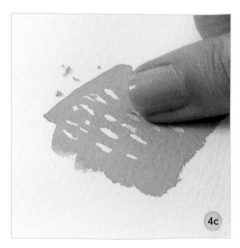
4c

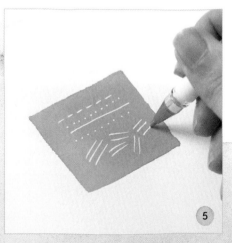
5

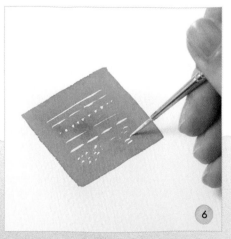
6

Paint Splatters

Adding splatters of paint to your work can give your piece a fun, interesting finish. They work well with loose paintings, or they can be used for a more specific purpose like stars in a night sky when you want to add a lot of fine dots or marks.

There are a few different ways that you can create splatters, using your brushes, a toothbrush, or a speckling brush. Clear a bit of space around your painting or lay down some scrap paper so you don't get the paint on other pieces of work. If you only want the splatter to go on a certain area, you can cut the shape out of a piece of scrap paper and lay it on top to protect the rest of the painting.

EXERCISE: USING A TOOTHBRUSH

2 Apply the paint to an old toothbrush or a firmer paintbrush, like a flat brush. Hold it about two inches from your painting and run your thumb or finger through the bristles. As the bristles flick back into place, a fine spray of paint will be released. Again, the more paint and water you have in your brush, and the closer you are to the paper, the larger the spray will be. You may need to practice to get the position right as it can be a bit unpredictable where the paint will go!

EXERCISE: TAPPING YOUR BRUSHES

1 Load your brush with paint then tap it against another brush over your paper. The larger the brush and the more water you have in your brush, the bigger the splatters will be. The harder you tap the more paint will be released as well.

EXERCISE: USING A SPECKLING BRUSH

3 You can also use a speckling brush to create a fine spray, perfect for a starry night sky. Apply the paint to the bristles with your paint brush, then turn the handle which moves the wire through the bristles.

For the best results, make sure your painting is completely dry before you add the splatters. Additionally, afterwards, be careful not to smudge any blobs of paint or water that may take longer to dry!

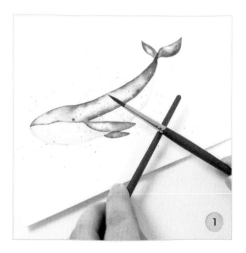

The Projects

In this chapter you will find a variety of projects where you can practice all of the techniques we have covered so far in the book. Some of the projects are quite quick and simple, and some will take a little longer. These longer projects still involve simple processes, so they are not more technical or advanced, they just have more repetitive elements in them—perfect for when you want to lose yourself in a longer, mindful painting session.

The projects also offer ideas for how you can incorporate watercolor into your daily life, by making simple gift tags, bookmarks, cards for friends and family, and pieces to display on your wall. Keeping your paintings around your home will bring you joy and inspire you to paint even more!

Remember to go at your own pace, enjoy the process and be kind to yourself! Refer back to the mindset tips and the techniques section as you need to.

Happy painting!

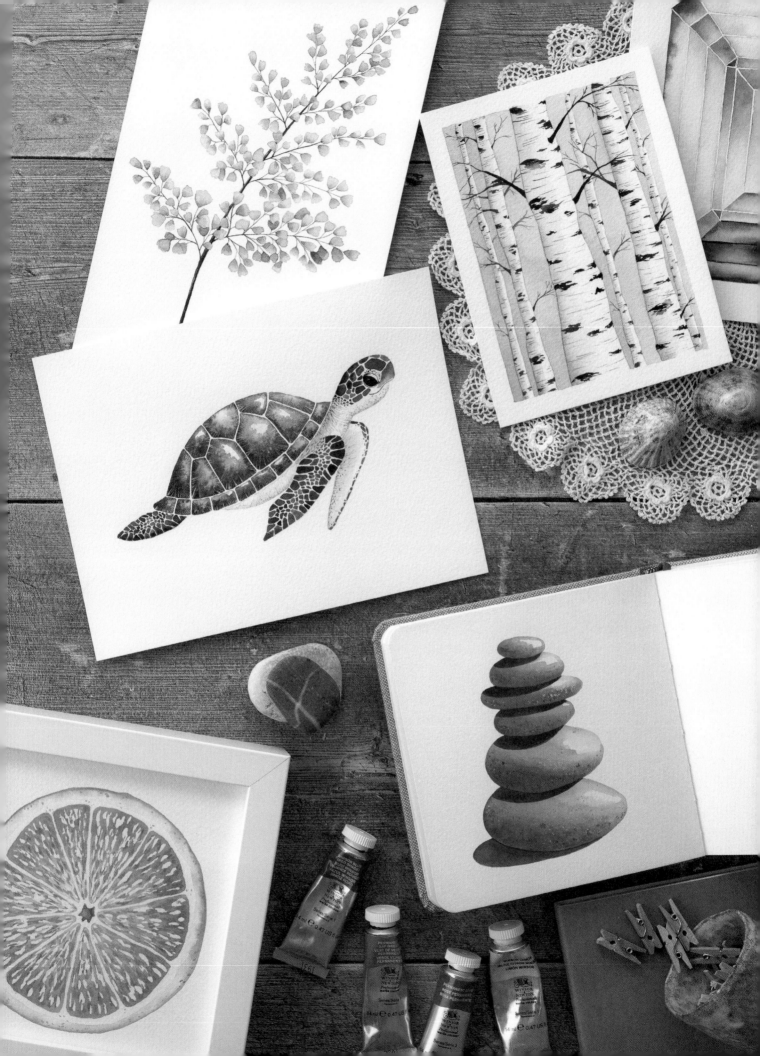

Layered shapes

Painting simple shapes can be incredibly therapeutic. The repetitive patterns, the harmonious color themes, the transparent layers, and the simplicity of the subject all combine to give you twenty minutes of fun, mindful painting. Making your artwork into bookmarks also gives a bit of structure and purpose to the paintings, so they can calm and inspire you as you see them around your home. Be warned though, they can become very addictive!

You will need

- Watercolor paper
- Water
- Paper towel

FOR THE BOOKMARKS
- Pencil & eraser
- Ruler
- Scissors or cutting tool
- Hole punch
- Twine or ribbon

BRUSHES:
- Size 4 round brush

PAINTS:

Winsor Blue (Red Shade) Winsor Lemon

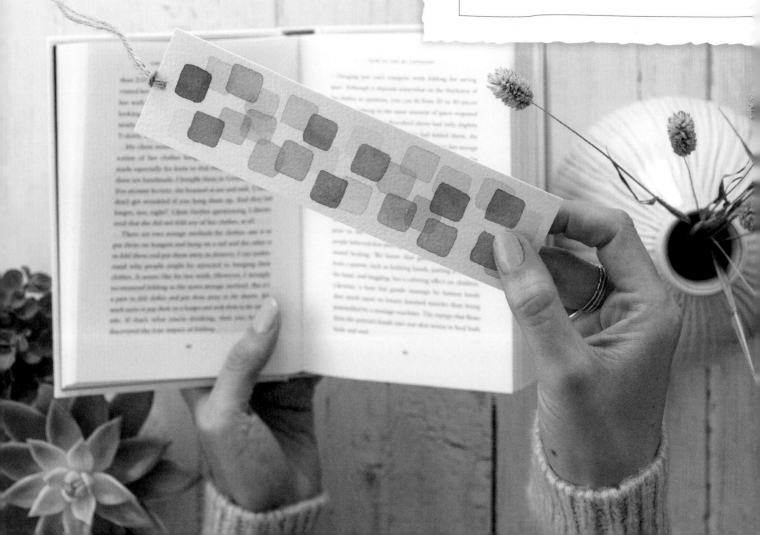

Mixing your colors

Add yellow to one side of your palette and blue to the other. Mix a variety of colors, as shown, in the space between. This will allow you to create a beautiful and harmonious combination of colors for your painting, fro[m]
to cooler blu[e]

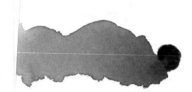
...llow more blue →

For the first l[ayer]
by diluting th[e]
layer (step 4[)]
more paint in

A gift for you

Merry Christmas and happy New Year!
From Katrina and Zoe

PRACTICING

1 Practice painti[ng]
 separate piece[s]
 you start your
 the squares fai[...]
 painting indivi[dual]
 edge (as we di[d in]
 Painting Shapes when we
 practiced squares), include the
 corners within your stroke. This will
 give a slight curve to them. Once
 you have painted the outline, fill in
 the center.

 pencil...
 a guide for where to paint
 and we will erase it once
 we're finished.

*Painting simple
shapes can
be incredibly
therapeutic.*

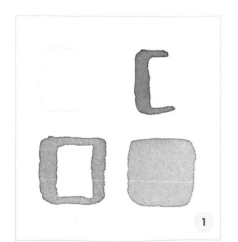

1

2

PAINTING YOUR BOOKMARK

3 With a size 4 round brush, paint a layer of pale squares inside the border of the bookmark in a random pattern using a range of yellow-greens, mid-greens, and blue-greens from your palette (see *Mixing your colors*). As you need to, dry your brush on the paper towel, then use it to lift any excess water from the paper. Wait until these squares have dried completely before moving onto the next layer.

4 Once the first layer has dried, you're ready to paint more squares over the top. Use slightly darker, more concentrated mixes this time (see *Mixing your colors*), and overlap the lighter squares underneath. Again, use a range of mixes by varying the amount of blue and yellow.

5 Once everything has dried, erase the pencil line border, punch a hole at the top of the bookmark, and add some ribbon or twine!

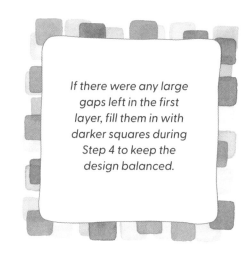

If there were any large gaps left in the first layer, fill them in with darker squares during Step 4 to keep the design balanced.

3

4

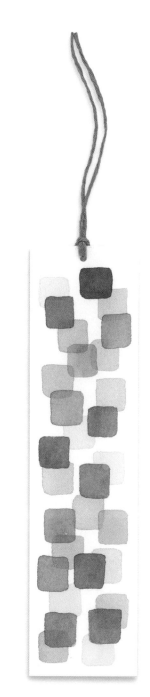

5

More inspiration

You can try this project with so many different combinations of colors and shapes. Try circles, rectangles, triangles, hearts, or simple leaves. Remember that softer, organic shapes will naturally be more pleasing to the eye and calming to look at, so you may want to avoid sharp edges. For colors, experiment with different palettes (see *Mixing Colors: Color Palettes*). There are so many possibilities! I like to keep a stock of blank bookmarks cut out and ready to go so that I can grab one whenever I feel inspired to paint.

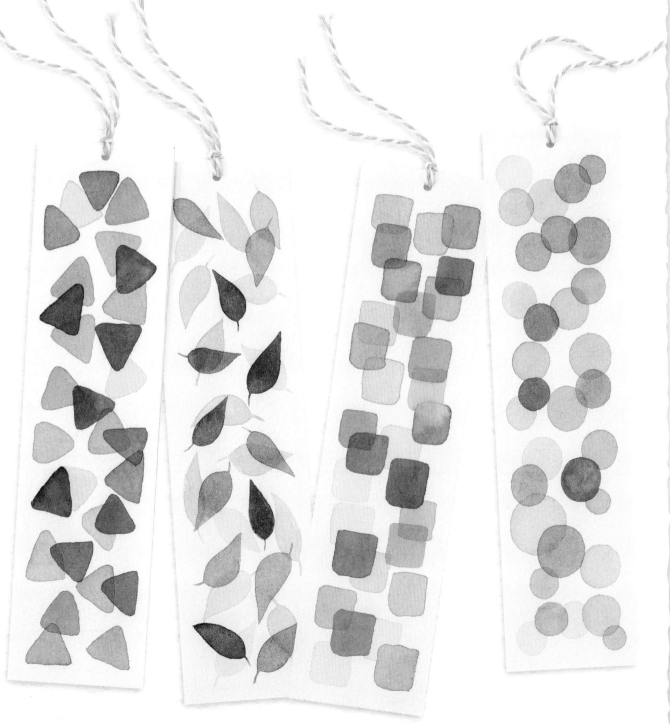

Leaves

Leaves are one of my favorite subjects to paint when I want to relax. They allow you to slow down with calming, repetitive brush strokes. By varying their shape and size you can paint many different varieties, and by changing the colors they can easily turn into a subject for all of the seasons!

I encourage you to experiment and explore colors and styles to paint a whole page of different leaves and branches. When you're feeling confident, you can make cute gift tags like the examples below or try out the wreath in *The Projects: Leafy wreath*!

You will need

- Watercolor paper
- Water
- Paper towel

FOR THE GIFT TAGS (OPTIONAL):

- Pencil & eraser
- Ruler
- Scissors or cutting tool
- Hole punch
- Twine or ribbon

BRUSHES:

- Size 2 round brush
- Size 4 round brush
- Size 6 round brush

PAINTS:

Winsor Blue (Red Shade) Winsor Lemon Permanent Sap Green

Permanent Rose Yellow Ochre Indigo

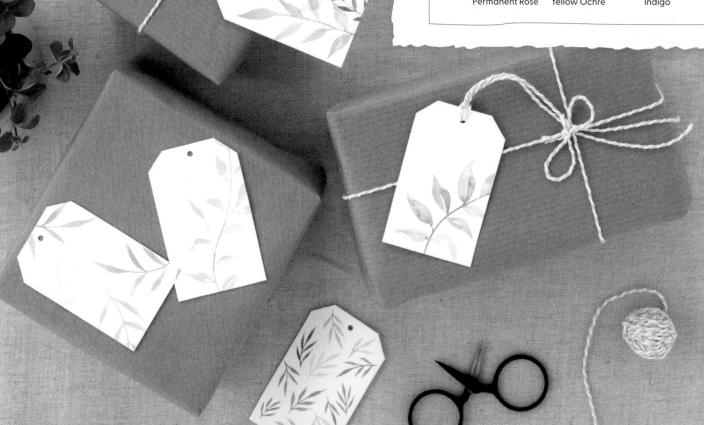

Mixing your colors

Greens can be really fun to mix because there are so many beautiful varieties and they are also naturally calming to look at while you paint. Try mixing different blues and yellows together, varying the ratios of each color in the mix, or start with a pre-mixed green like Permanent Sap Green and add a yellow or blue to it to make it warmer or cooler. To make the greens more muted, you can add a touch of the complementary color (red) to the mix or use a blue or yellow that have red undertones, like Indigo and Yellow Ochre. Refer back to the color wheel in *Mixing Colors: The Color Wheel* for more on mixing, and check the key, right, to see the combinations that I used.

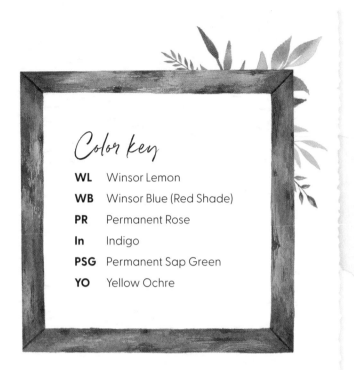

Color key

WL	Winsor Lemon
WB	Winsor Blue (Red Shade)
PR	Permanent Rose
In	Indigo
PSG	Permanent Sap Green
YO	Yellow Ochre

WARM GREENS

Warm greens are great for fresh spring and summer foliage. They're made by mixing a lot of yellow with a little blue. Start with the yellow and then gradually add a small amount of the blue. Mixes 4 and 5 start with a pre-mixed green, and then have yellow added to them.

MID GREENS

Mid-greens are neither warm nor cool, and are mixed with a more even ratio of yellow and blue. Experiment with these mixes to get a variety of mid-greens, adding a touch of red to some to make the color more muted.

COOL GREENS

These cool greens are great for darker foliage in winter, and they're made with lots of blue and a little yellow. Mixes 4 and 5 start with a pre-mixed green, and then have blue added to them.

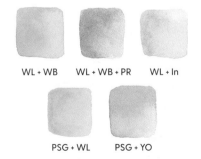

WL + WB WL + WB + PR WL + In

PSG + WL PSG + YO

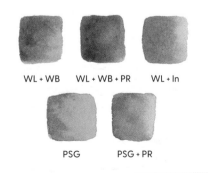

WL + WB WL + WB + PR WL + In

PSG PSG + PR

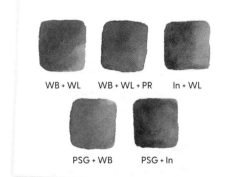

WB + WL WB + WL + PR In + WL

PSG + WB PSG + In

SINGLE-STROKE LEAVES

1. For a single-stroke leaf, start with the tip of the brush on the paper, and in one smooth motion slowly add pressure, then gently ease the pressure again as you drag the brush across the page. Finish by bringing the stroke to a point, then lifting the brush away.

2. To paint a branch of single-stroke leaves, begin by painting a thin curved line with the tip of your brush. At the end of the line, add a single-stroke leaf as before.

3. Practice painting some leaves with a short stem **(3a)**, then add these to either side of the branch until it is full **(3b)**.

4. Now practice longer single stroke leaves. These are great for painting pot plants like the palm leaf (see *Connecting With Your Practice* for an example).

Subtle variations in direction of the leaves at either side of a branch will add much more movement to your branches and make them look more natural.

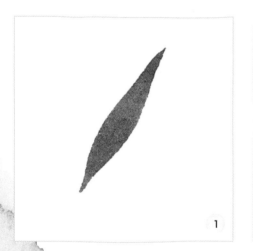

1

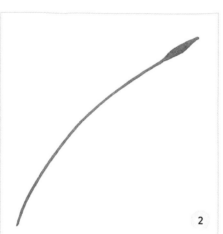

2

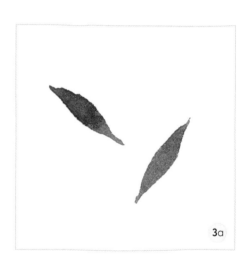

3a

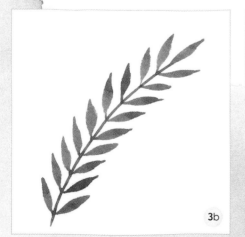

3b

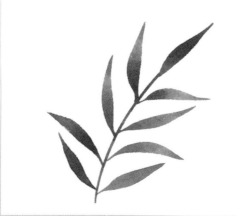

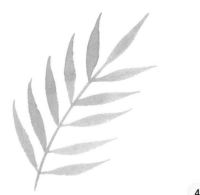

4

TWO-STROKE LEAVES

1 For two-stroke leaves, we will use 'C' curves and 'S' curves. For a 'C' curve, as you apply pressure, curve the brush around slightly to form a subtle 'C' shape **(1a)**. Now try this in the opposite direction **(1b)**.

2 Practice combining these two strokes, leaving a thin gap in the center to give you a highlight that represents the vein of the leaf.

3 For leaves on the side of a branch, we can use a 'C' curve with an 'S' curve to create the illusion that the leaf is bending slightly. To practice an 'S' curve, start at the bottom and apply pressure as you curve the brush in a slight 'S' shape, releasing the pressure gradually before you get to the tip.

4 Practice joining a 'C' curve and an 'S' curve together, again leaving a gap in the center for the vein.

5 For a bit of variety, try leaving a gap at the base of the leaf so the strokes only join at the top. While the paint is still wet, add a little darker paint into the base of the leaf so that it blends in and creates a nice gradient.

6 For a branch, start with a curved line. At the top, paint a leaf with two 'C' curves. For the leaf on the right side, paint a 'C' curve bending over to the right, followed by an 'S' curve underneath. Repeat on the left in the opposite direction.

1a

1b

2

3

4

5

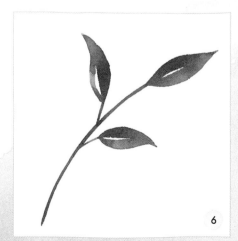

6

SOLID LEAVES

1 For solid leaves, paint the outer edges of the leaf with C curves, then fill in the center with an extra stroke. For a branch, paint a thin curved line, with a leaf at the end, then paint leaves on either side.

2 Try this again with shorter, rounder leaves. Using these in combination with the leaves from step 1 can make your overall piece look much softer and more pleasing to the eye.

ADDING MOVEMENT AND INTEREST

1 Experiment with creating some variations of values within your leaves, by either lifting out some of the paint at the top of the leaf or dropping in more paint to make an area darker.

2 Paint the stem with a concentrated color. With a clean, wet brush, paint the leaves, touching the stem at the beginning of each stroke. Watch how the color from the stem bleeds into the leaves. So relaxing!

3 Try painting the leaf first and then add the stem, pushing the paint from the stem into the base of the leaf while it is still wet. Experiment and have fun with all of these different effects!

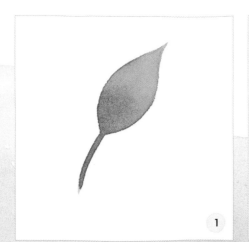

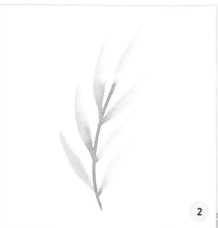

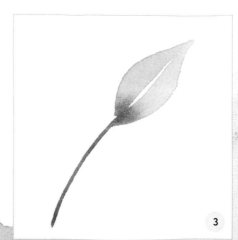

More inspiration

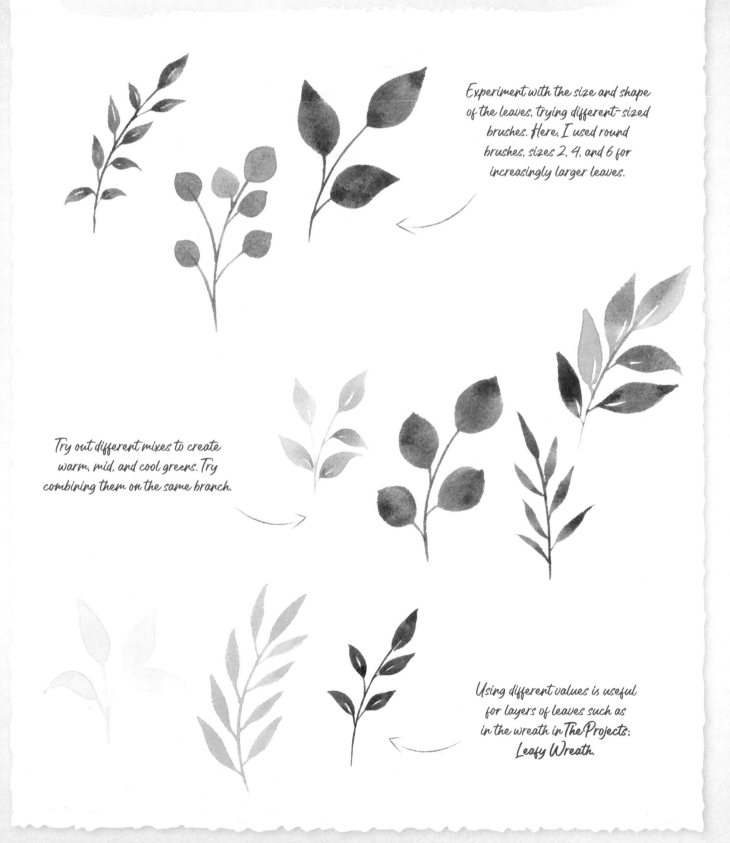

Experiment with the size and shape of the leaves, trying different-sized brushes. Here, I used round brushes, sizes 2, 4, and 6 for increasingly larger leaves.

Try out different mixes to create warm, mid, and cool greens. Try combining them on the same branch.

Using different values is useful for layers of leaves such as in the wreath in *The Projects: Leafy Wreath.*

Jellyfish

There is something I find really relaxing about painting sea life. With this jellyfish, you can just imagine it gently floating along with the current. It is one of the quickest and simplest projects in the book, yet is still really fun and allows you to experiment with different techniques, including wet-on-wet and wet-on-dry layers.

You will need

- Watercolor paper
- Water
- Paper towel
- Pencil & eraser

BRUSHES:
- Size 4 round brush

PAINTS:

Indigo

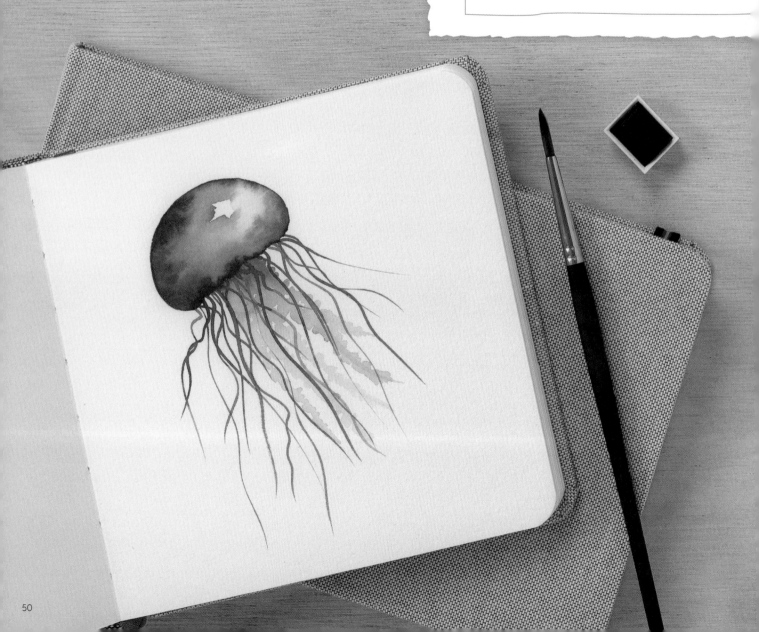

Mixing your colors

This project uses just one color (Indigo), allowing you to practice using different values to create contrast. Dilute the paint with more water for step 3 and use a more concentrated color for step 4. Head to *Mixing Colors: Values* for more tips on mixing different values.

more diluted

DRAWING THE JELLYFISH

1 With your pencil, start by drawing the bell of the jellyfish. This is a semi-circle with rounded corners and a jagged edge underneath. Soften the pencil line with your kneaded eraser before you start painting.

PAINTING THE JELLYFISH

2 With a size 4 round brush, add some clean water to the bell, leaving a dry patch in the top right corner for a white highlight. Avoid going too close to the outline with the water so that you can achieve crisper, darker edges by painting wet-on-dry there. While the water is still wet, add a concentrated Indigo to the edges of the bell so that it bleeds into the wet paper. Add more Indigo around the edges to darken, especially on the left side and at the bottom. Tip the page in different directions to encourage the paint to run. If you need to, you can dab a paper towel onto the paper in the center of the bell to lift some of the color for more of a highlight.

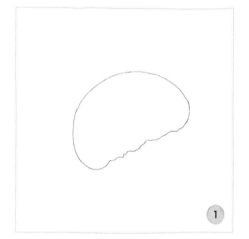

*If the color runs too much when you tip the page, you have too much water on the paper so pick it up with a clean, dry brush. Head to **Watercolor Basics: Water Control** for more tips on this.*

3 With your size 4 brush again, use a diluted Indigo to paint the arms. One at a time, paint five lines and then add marks coming out of either side. Add a little more Indigo to the top of the arms, underneath the bell, for a bit of a shadow.

4 Once the arms are dry, use a concentrated Indigo to paint the wavy lines coming out from under the bell for the tentacles. Painting these in different directions and slightly shorter on the outer edges will give the jellyfish more movement and that "floaty" appearance.

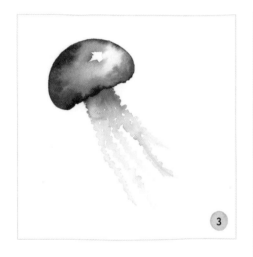

3

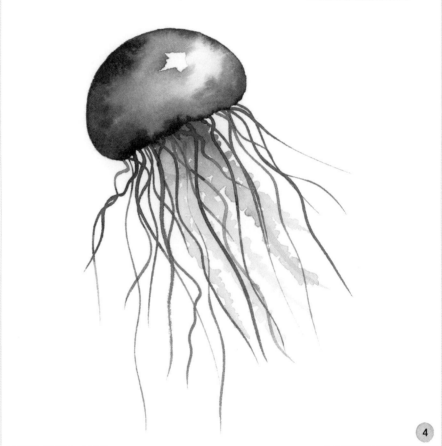

4

More inspiration

Paint more jellyfish, experimenting with different colors! This is a great subject for when you want something to paint that doesn't take too long. You could also paint a few huddled together and frame it for a piece of wall art. In this piece I used Winsor Blue (Red Shade) and Permanent Rose, varying the ratios for each jellyfish to achieve different colors.

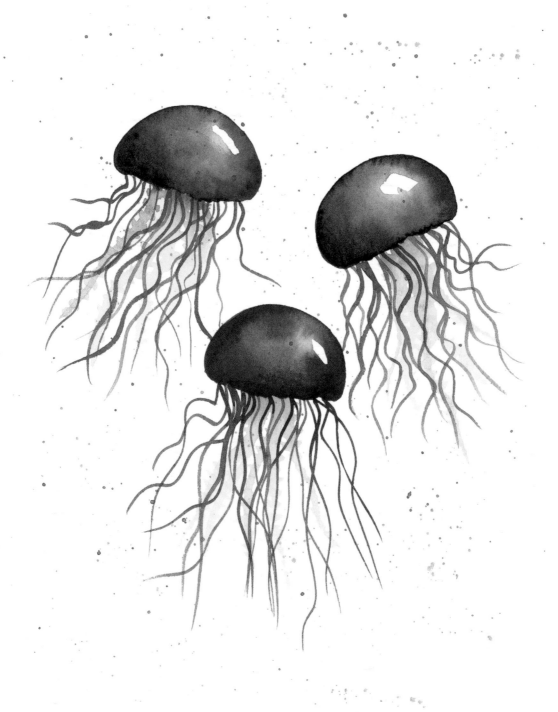

Whale

This cute whale is one of the easiest and quickest projects in this book. It's not only fun to paint but also calming to look at with the soft blends of the wet-on-wet technique. You can turn this into a lovely piece of wall art or a greeting card!

With most paintings, I recommend starting with the areas that are lighter, like the belly of the whale, before adding the darker colors into the adjacent areas. If you paint the dark areas first, you risk accidently reactivating that color if it gets wet when you paint the lighter areas, resulting in it bleeding into them.

You will need

- Watercolor paper
- Water
- Paper towel
- Pencil & eraser
- Opaque white paint (optional)

BRUSHES:

- Size 0 round brush
- Size 4 round brush
- Liner brush

PAINTS:

Indigo

Permanent Rose

Winsor Lemon

Ivory Black

Mixing your colors

For the underside of the whale, make a diluted gray by mixing your Indigo and Permanent Rose together to make purple and then adding a little yellow. Dilute it with lots of water.

Mix 1

In + PR + WL

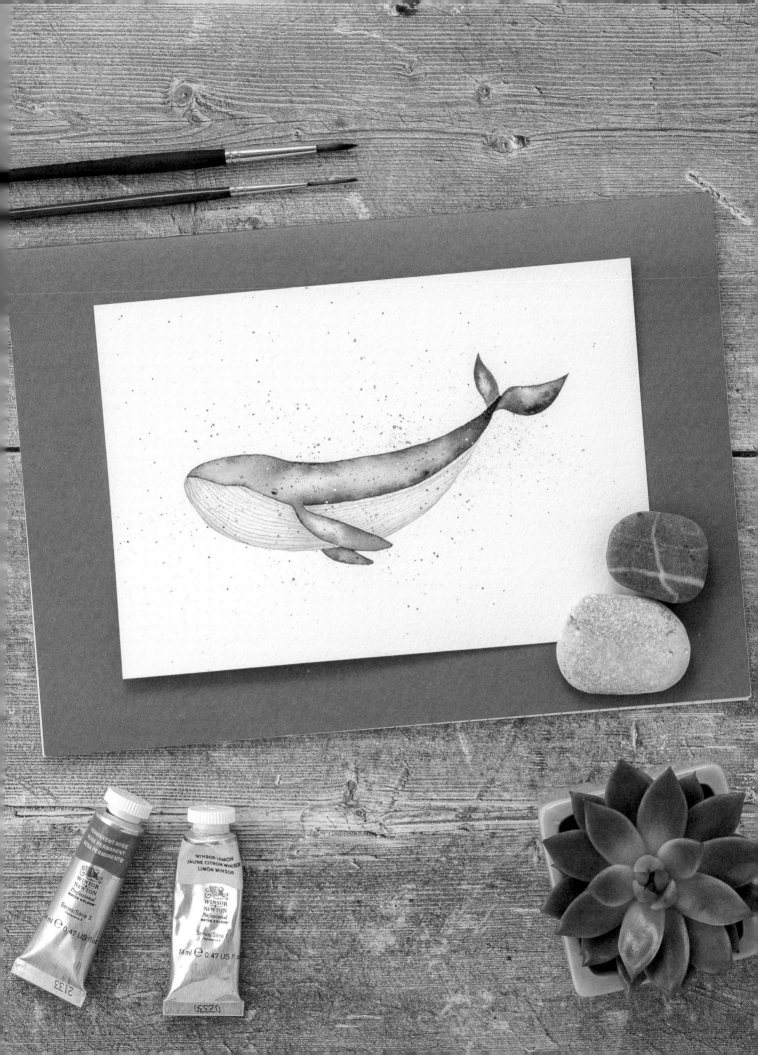

DRAWING THE WHALE

1 With your pencil, lightly draw the outline of the whale. Start with the outer edges and then add a line down the center. Draw in a fin, with the closest one starting at the central line, and then a second smaller fin coming down from the bottom line. Next, draw in the flukes of the tail, making the one on the right side larger so it appears closer. Lastly, draw in a small circle for the eye with a curved line above it. Use your kneaded eraser to lighten the pencil lines before you start painting.

PAINTING THE WHALE

2 Now we are ready to paint, we will start with the shadow on the underside of the whale. For this, mix up a diluted blue-gray like Mix 1 (see *Mixing your colors*). Using a size 4 round brush, add clean water to the center of the underside, avoiding the edges. While still wet, add the diluted gray to the edges so that it bleeds into the wet area creating a soft transition.

3 Wait until the underside is dry before painting the top of the whale. As before, add water to the center of the top half of the whale and the fin, avoiding the edges. Add Indigo around the edges so that it bleeds into the wet area. Go over the edges with a deeper more concentrated Indigo while it is still wet to create a stronger contrast. If the water starts to dry in the middle you may need to add some more as you go along. Don't worry too much about getting patches or back runs on this because it will add to the markings in the whale's skin.

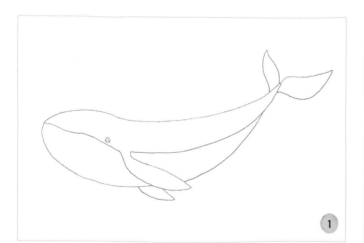

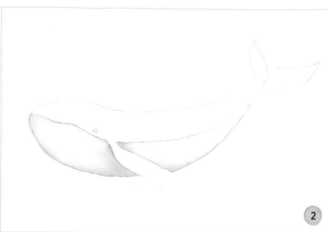

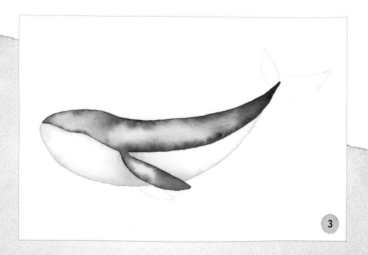

4 Once that has dried, use the same method to paint the tail and the other fin, adding clean water to the inside and then painting around the edges with the Indigo so that it bleeds in. You may wish to drop down to a smaller size brush for these smaller areas.

5 With a size 0 round brush, use Ivory Black to paint the eye with a thin line above it. Then switch to your liner brush and paint thin lines along the underside of the whale using the Indigo.

6 To finish, add some splatters of paint using your Indigo and opaque white. I have added bigger splatters by tapping my brush on another brush, then added finer splatters running my thumb through a flat brush.

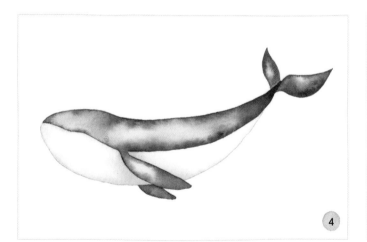

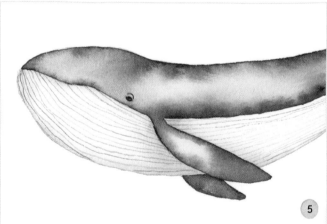

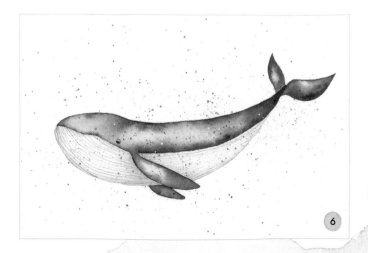

*Head to **Techniques: Paint Splatters** to find out more about adding splatters like this to your work! They are great for adding movement and fun to your finished piece.*

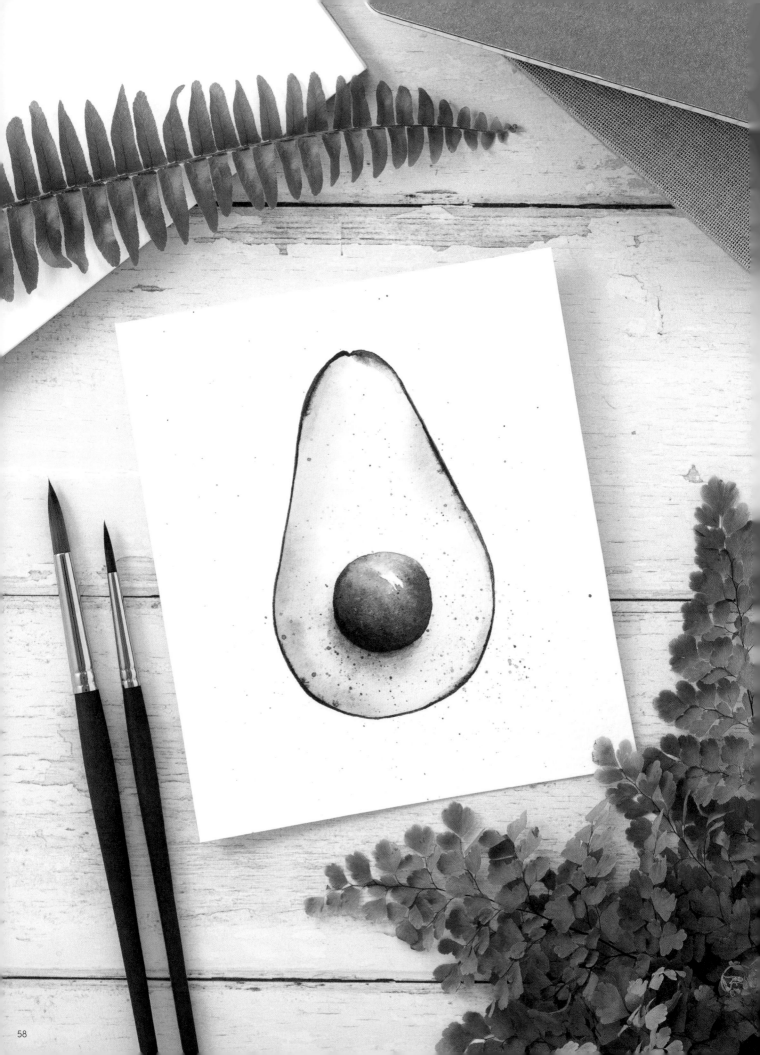

Avocado

Avocados are a fun and quite simple fruit to paint, with their beautifully contrasting colors and textures. The dark outer skin combined with the yellow-green fruit and the brown stone gives you a lot of opportunity to play with the wet-on-wet technique and manipulating values.

With any projects that have wet-on-wet areas like this, it's good to practice letting go a little of having control. No two paintings will turn out the same—which is exciting and wonderful! Embrace these effects and have fun with it.

You will need

- Watercolor paper
- Water
- Paper towel
- Pencil & eraser

BRUSHES:

- Size 2 round brush
- Size 8 round brush
- Size 4 round brush

PAINTS:

Permanent Sap Green

Winsor Lemon

Burnt Umber

Indigo

Mixing your colors

Add a little Indigo to Burnt Umber for a dark brown for the darkest edge of the stone.

Mix 1

BU + In

DRAWING THE AVOCADO

1 With your pencil, draw the outline of the avocado. Start with a circle for the stone and then, for the outer edge, draw an egg shape that is narrower at the top. Remove any excess pencil with your kneaded eraser before you start painting.

PAINTING THE AVOCADO

2 Using the wet-on-wet technique, paint the green part of the avocado with a size 8 round brush. For this you will need Winsor Lemon, Permanent Sap Green and Indigo. First, add clean water to the fruit area, avoiding getting too close to the edges. Add some fairly diluted yellow across the wet area, leaving a little white paper. While this is still wet, add the green around the edges. Finally, add in a little diluted Indigo underneath the circle of the stone for a shadow, and to some parts of the edges. Be careful not to go overboard with the Indigo and make it too dark.

3 Once that is dry, you can paint the stone using the wet-on-wet technique again and a size 4 round brush. For this, prepare your Winsor Lemon, Burnt Umber and Mix 1 (dark brown, see *Mixing your colors*). Start with a diluted Winsor Lemon, leaving a patch of white for a highlight in the top right **(3a)**. While still wet, add Burnt Umber, leaving a small patch of the yellow visible around the highlight **(3b)**. Add the dark brown mix around the edges, particularly at the bottom left **(3c)**. This contrast will give dimension to the stone, making it pop out from the page.

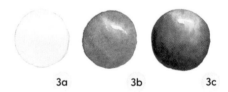

3a 3b 3c

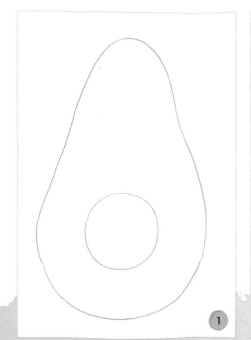

1

2

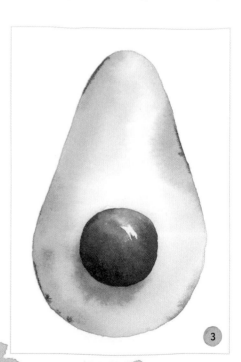

3

4 Switch to a smaller size 2 round brush and paint the skin around the edge of the avocado using a concentrated Indigo so that it stands out against the green. While it's still wet you can add a touch of clean water on some of the inner edges to make some parts of the edge bleed in. Add some concentrated Indigo to the bottom left of the stone for more depth and a greater contrast. If you need to, darken the shadow underneath the stone with the Indigo as well and then soften the edge with a clean damp brush.

5 To finish, add some green, brown and Indigo splatters! To do this, tap your brush against another brush (see *Techniques: Paint Splatters* for more deail on this technique). Vary the size of the brush you are using to achieve different sized splatters.

Remember that different parts of your painting may require a different sized brush. Eventually it will become second nature to switch between brushes as you paint, knowing which size will work best for which part. It will all come with practice!

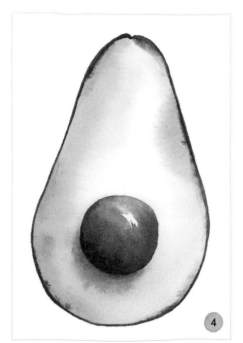

4

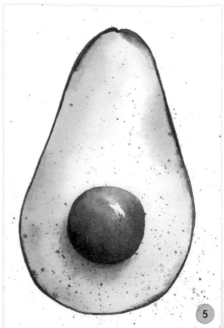

5

There is so much inspiration for painting to be found in the kitchen. Have a look in your fruit bowl or in your fridge to find more fun subjects to paint!

Carrots

Carrots are a fun, vibrant vegetable to paint in watercolor with interesting texture and bushy leaves. Use this project to practice the wet-on-wet technique, building up the color for depth and dimension.

You will need

- Watercolor paper
- Water
- Paper towel

BRUSHES:

- Size 2 round brush
- Size 8 round brush

PAINTS:

Winsor Lemon

Permanent Rose

Burnt Umber

Winsor Blue
(Red Shade)

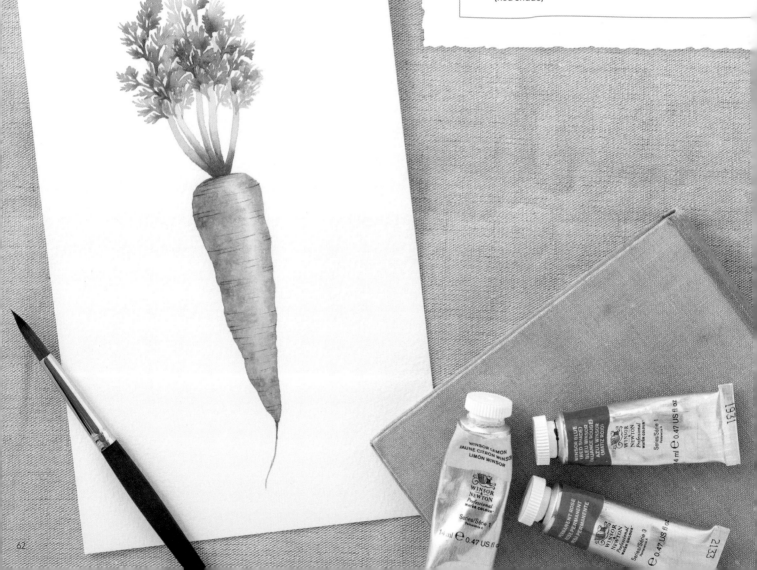

Mixing your colors

For the body of the carrot, make a yellow-orange (Mix 1) by adding a little Permanent Rose to Winsor Lemon and a bolder, brighter orange (Mix 2) with more Permanent Rose.

For the leaves, make a yellow-green (Mix 3) by adding a little Winsor Blue (Red Shade) to Winsor Lemon. Make a more muted green (Mix 4) by mixing a green and then adding a little Permanent Rose. Mix a muted blue-green (Mix 5) by adding more blue to Mix 4.

For the final details, mix a dark brown (Mix 6) by adding a little Winsor Blue (Red Shade) to Burnt Umber.

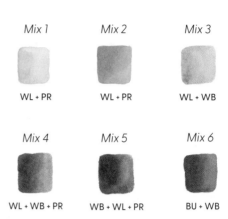

Mix 1	Mix 2	Mix 3
WL + PR	WL + PR	WL + WB

Mix 4	Mix 5	Mix 6
WL + WB + PR	WB + WL + PR	BU + WB

PAINTING THE CARROT

1 For the body of the carrot, we will use the wet-on-wet technique with Mix 1 (yellow-orange), Mix 2 (orange) and Burnt Umber, so prepare your colors on your palette before you start. If you prefer to, you can draw the outline of the carrot before you start painting. Using a size 8 round brush, start with a diluted Mix 1 to paint the base of the carrot. While still wet, add Mix 2 to the edges, leaving a lighter strip on the right-hand side to give the carrot dimension. You can lift some of the paint here if you need to. Add more Mix 2 and some Burnt Umber to the edges to build up the color. Dab a little Burnt umber near the edges to darken them and add texture. With the Burnt Umber, add a thin line at the bottom of the carrot using the tip of your brush.

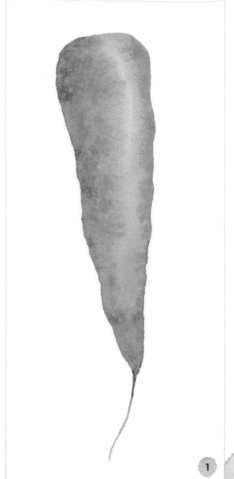

2 Prepare mixes 3, 4 and 5 (see *Mixing your colors*) for the foliage. Using a size 2 brush and a diluted Mix 3 (yellow-green), paint five branches at the top of the carrot. While still wet, drop some Mix 4 (muted green) into the bottom where they meet.

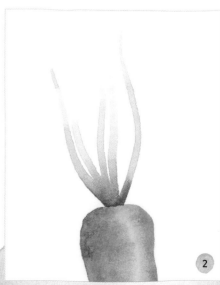

3 Starting about halfway up each branch, using your size 2 brush, paint short branches of leaves. Start with a diluted Mix 3 (yellow-green) and paint a curved line with a couple of smaller lines coming off each side **(3a)**, then press your brush down in a quick dabbing motion to create leaves on either side of each of these shorter lines **(3b)**. Drop in some darker color from either Mix 4 (muted green) or Mix 5 (muted blue-green) to the base so it bleeds in **(3c)**. Repeat until all of the branches are covered in leaves from halfway upwards. Add some thin lines of green between each stem that comes out of the carrot to separate them slightly **(3d)**.

4 Using a size 2 round brush again, paint short, fine horizontal lines across the carrot using Mix 6 (dark brown). Start from the edges for most of the lines and then add some in the center as well. Make the lines different lengths with varying gaps in between so they don't look too uniform. To keep these nice and fine, remember to take the excess water out from your brush before you paint.

There are so many fun fruits and vegetables to paint, with interesting markings, colors and leaves! Have a look in your kitchen or when you next go food shopping for inspiration.

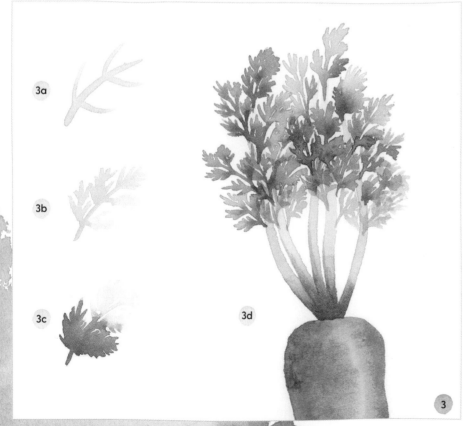

3a

3b

3c

3d

3

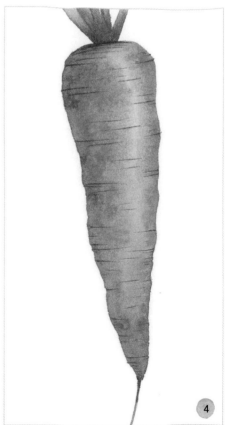

4

More inspiration

These carrots would make a beautiful piece of wall art for your kitchen—just paint three or five next to each other (odd numbers are always good) and frame it!

Potted plants

These three-step potted plants are a fun and simple "doodle" project. They are quick, easy and allow you to practice a variety of watercolor techniques on a small scale, from color mixing to wet-on-wet and fine details. Just choose a pot shape and paint the base color, add some fun patterns and then finish it off with a simple plant, similar to those that we practiced in Leaves. Have a go at these ones and then design more of your own!

Keep your eyes open for any patterns that inspire you. There are patterns everywhere! Doodle ideas in a notebook so you can refer back to them later when painting.

You will need

- Watercolor paper
- Water
- Paper towel

BRUSHES:

- Size 0 round brush
- Size 2 round brush
- Size 4 round brush

PAINTS:

Winsor Blue (Red Shade)

Winsor Lemon

Permanent Rose

Burnt Umber

Indigo

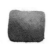
Payne's Gray

Mixing your colors

Pots: For Mix 1 (base) add a little yellow to blue. For Mix 2 (base), make a gray using all three primary colors. For Mix 3 (patterns), make a dark brown by adding a little Indigo to Burnt Umber.

Plants: Mix a variety of greens with your primary colors. Mix 4 has more yellow, and Mix 5 has more blue. Mix 6 is a diluted blue-green, with slightly more blue and a touch of red. Mix 7 is a bolder, muted green with an even amount of yellow and blue, and a touch of red.

Mix 1

WB + WL

Mix 2

WB + PR + WL

Mix 3

BU + In

Mix 4

WL + WB

Mix 5

WB + WL

Mix 6

WB + WL + PR

Mix 7

WL + WB + PR

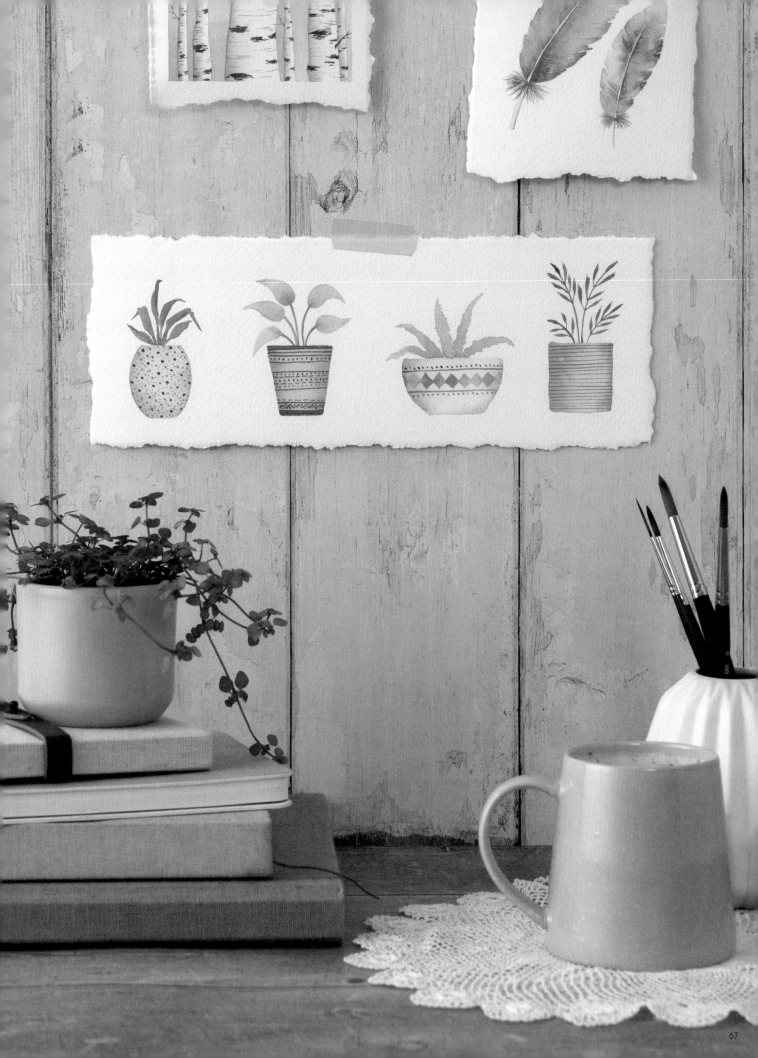

PAINTING THE BASE

1 Choose a plant pot shape and your base color. This can be as simple as a square or rectangle. Using a size 4 brush, paint the shape with a diluted mix of paint and then add a slightly more concentrated mix of the same color down the side edges so that it bleeds into the wet surface. This will add a bit of dimension to your pot. These pots are only small, about ¾–1⅛in (2–3cm) high, so if you are painting them larger remember to use a bigger brush!

Try out different plant pot shapes by changing the angle of the side edges, adding curves or by changing the height or width of the pot.

1 Pot 1: Mix 1 Pot 2: Burnt Umber Pot 3: Payne's Gray Pot 4: Mix 2

ADDING SOME PATTERNS

2 Once dry, add some details and patterns to the pots. The options are endless and you can have fun trying out different designs, making them as simple or detailed as you like! Try lines, dots, diamonds, and zig-zags. For this step, I used a size 0 round brush. Remember to take the excess water out of your brush to give yourself more control.

2 Pot 1: Indigo Pot 2: Mix 3 Pot 3: Payne's Gray Pot 4: Payne's Gray

ADDING A PLANT

3 For the final step, add simple plants using the brush strokes that we practiced in Leaves. I used my size 2 round brush for these.

For Pot 1, using Mix 7 (bold, muted green), wobble your brush slightly while painting these leaves to give them more of a rough finish, flicking the end of some of the leaves downwards.

For Pot 2, use Mix 4 (yellow-green) for the leaves and then while still wet add in Mix 5 (mid-green) to the stems and base of the leaves.

For Pot 3, use a diluted Mix 6 (blue-green) and paint jagged edges along the leaves.

For Pot 4, paint four single stroke branches like we practiced in the leaves project using Mix 5 (mid-green).

Design your own, making them as simple or as detailed as you like!

Experiment with different pot shapes and try out different patterns using the simple strokes and shapes we practiced in the Techniques section. There really is no limit to how many variations of these you can paint, and they are a great subject to turn to when you want a little watercolor "doodle" session.

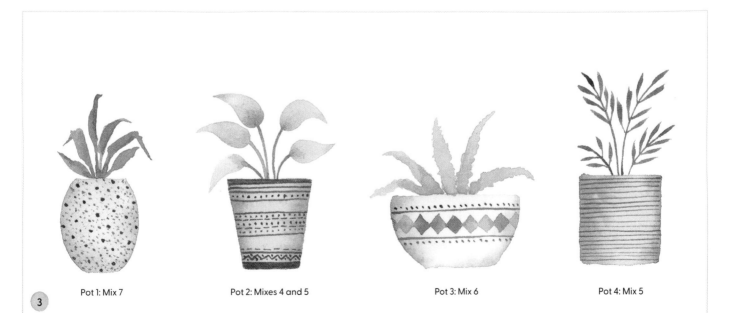

3 Pot 1: Mix 7 Pot 2: Mixes 4 and 5 Pot 3: Mix 6 Pot 4: Mix 5

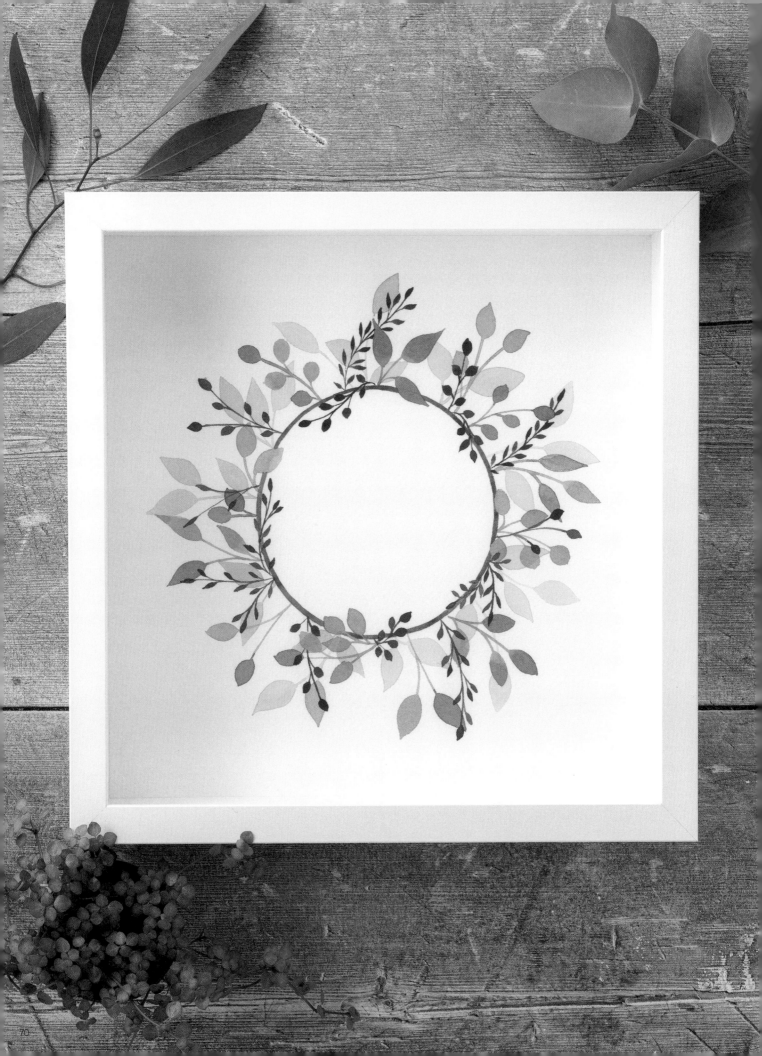

Leafy wreath

By combining leaves like those we painted in *The Projects: Leaves*, we can make beautiful borders and wreaths. I like to build the layers up using different values, with slight variations of different greens. They can be lovely on their own, or you can add some lettering in the center—perfect for wall art or greetings cards.

As you mix more paint for more leaves, the colors will change slightly and that's OK! Having subtle variations of color throughout the painting will make it look more interesting and dynamic.

You will need

- Watercolor paper 8in (20cm) square or bigger
- Water
- Paper towel
- Pencil & eraser
- Something circular to draw around approx. 3¼in (8cm) diameter

BRUSHES:
- Size 2 round brush
- Size 4 round brush

PAINTS:

Winsor Blue (Red Shade)

Winsor Lemon

Permanent Rose

Mixing your colors

These three greens are all mixed with the three primary colors, using slightly different ratios of each color.

For Mix 1, start by mixing Winsor Lemon and Winsor Blue (Red Shade) together to make a green, then add a touch of Permanent Rose to make it more muted. For Mix 2, make a slightly darker, cooler green by adding more blue to your yellow, again with a touch of pink. For Mix 3, make a bolder green, with your blue and yellow, using less pink this time.

Mix 1	Mix 2	Mix 3
WL + WB + PR	WB + WL + PR	WL + WB + PR

PAINTING THE WREATH

1 Draw a circle approximately 3¼in (8cm) in diameter in the center of your paper (the kitchen is a great place to find things to draw around!). Leave approximately 1⅝–2in (4–5cm) around the circle to give you enough space to add your leaves.

2 Add plenty of water to Mix 1 (muted green: see *Mixing your colors*) to dilute it, and then use a size 4 brush to paint the first leaves. Vary the length and number of leaves you add to each branch. Wait until these are dry to move on to step 3.

3 Using a slightly more concentrated version of Mix 1, paint in some more leaves, filling the gaps and overlapping some of the first leaves. Paint some branches bending over and falling into the circle and include some smaller, rounder leaves to soften the overall look. Wait until these are completely dry before moving on to step 4.

Every so often, pause and look at your painting to check how your wreath is progressing. You may find the leaves are longer on one side or that there's a gap. If so, just add a longer branch on the opposite side to balance it out or fill in the space!

The longer branches will help guide you as the painting develops because they will establish the maximum length of the remaining leaves, helping to keep the wreath well-balanced.

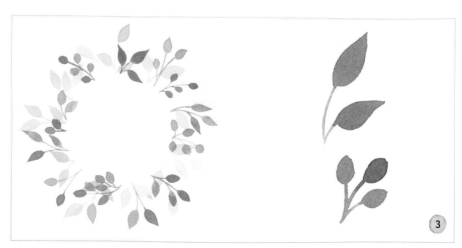

4 For the final layer of leaves, switch to your size 2 brush and paint Mix 2 (dark, cool green: see *Mixing your colors*). Use more paint and less water to make this green more concentrated so that it is darker than the previous layers. Paint in some smaller leaves with some of them bending into the circle.

5 We'll now use Mix 3 (bold green: see *Mixing your colors*) to paint the circle. Go slowly and avoid painting over the leaves that are falling into the circle. If you wish, you can finish it off by adding some lettering in the center.

More inspiration

Try more wreaths and borders using different shapes; squares or diamonds work well! You can also try different colored leaves for different times of year: try reds and oranges for fall and blues for winter.

You can also paint some of the darkest leaves around a few of the other leaves to make it appear as though they are sitting behind them.

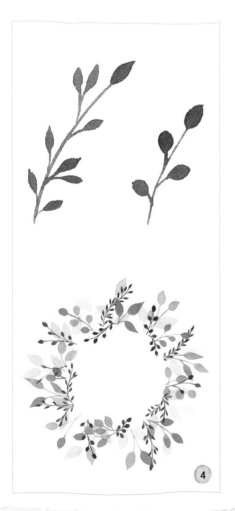

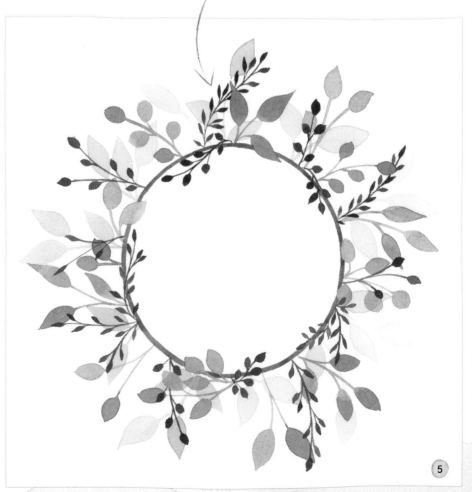

Pebbles

These pebbles are a fun project for practicing mixing a variety of beautiful grays and muted colors. They are also a great way to start practicing painting shadows, paying attention to where the light is coming from and understanding how to create depth and dimension to make something pop out from the page.

You will need

- Watercolor paper
- Water
- Paper towel
- Pencil & eraser
- Opaque white paint or gel pen

BRUSHES:

- Size 0 round brush
- Size 2 round brush
- Size 6 round brush

PAINTS:

Winsor Lemon

Permanent Rose

Winsor Blue (Red Shade)

Burnt Umber

Indigo

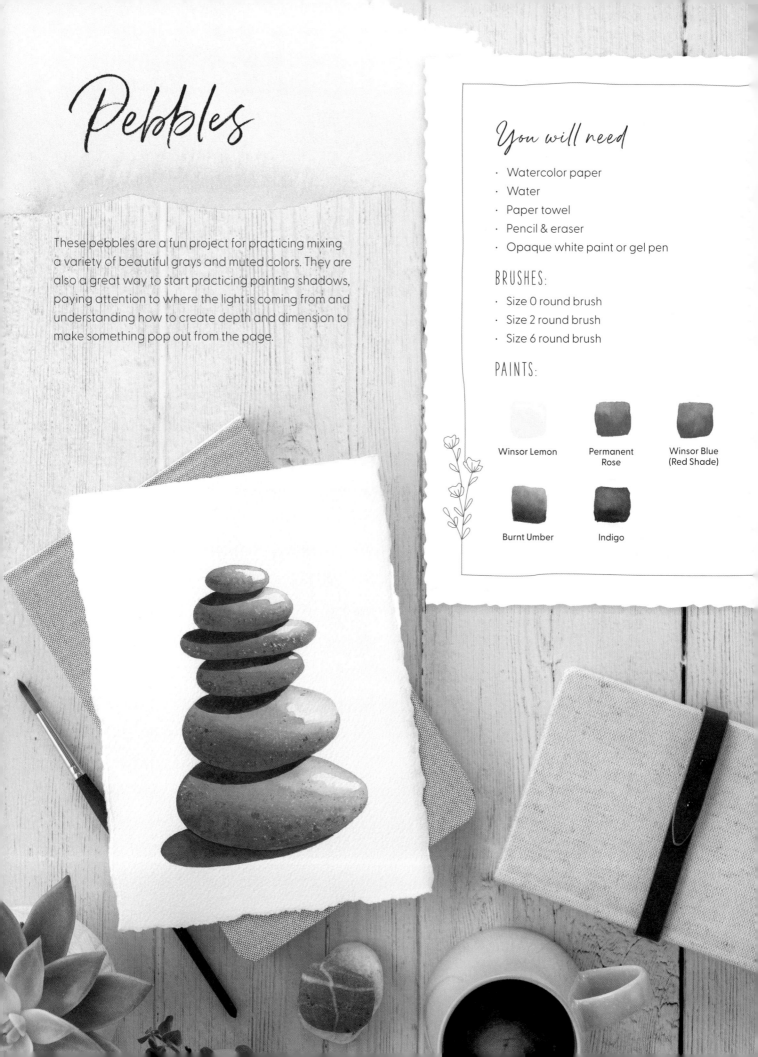

Mixing your colors

Mix a variety of browns and grays for the pebbles.

For Mix 1, mix a gray using Permanent Rose, Winsor Lemon and Winsor Blue (Red Shade) (Pebble 1). Add a little Indigo to Burnt Umber for Mix 2 (Pebble 3). Add more Indigo to Mix 2 for the darker brown of Mix 3 (Pebble 5). For Mix 4, mix a purple-gray by adding more Permanent Rose to Mix 1 (Pebble 2). Mix a blue-gray by adding a little Burnt Umber to Indigo for Mix 5 (Pebbles 4 and 6).

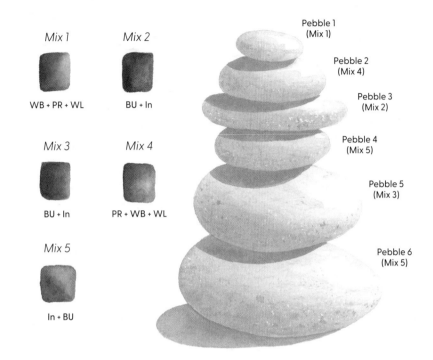

Mix 1

WB + PR + WL

Mix 2

BU + In

Mix 3

BU + In

Mix 4

PR + WB + WL

Mix 5

In + BU

Pebble 1 (Mix 1)

Pebble 2 (Mix 4)

Pebble 3 (Mix 2)

Pebble 4 (Mix 5)

Pebble 5 (Mix 3)

Pebble 6 (Mix 5)

DRAWING THE PEBBLES

1 Start by lightly drawing the pebbles, beginning at the top with the first one. Draw the second pebble so that the one above is overlapping it a little. Continue drawing all six pebbles, varying the sizes and then add a shadow at the bottom. Use your kneaded eraser to lighten any pencil lines before you start painting.

PAINTING THE PEBBLES

2 Use a size 6 brush to paint the pebbles using a variety of gray mixes. Start by painting every other pebble, so that they can dry before painting the rest. For Pebble 1 (at the top), use Mix 1 (gray: see *Mixing your colors*). For Pebble 3, use Mix 2 (brown). For Pebble 5, use Mix 3 (dark brown). For each pebble, leave a small white highlight in the top right corner (where the sunlight is hitting the pebbles) and add more color into the bottom for shadow, especially on the left side. This will help start to give the pebbles some form and dimension. Keep each mix separate on the palette as we will be returning to them later.

When adding dimension to your painting, be consistent with your highlights and shadows. Choose which direction the light is coming from (here it is coming from the top right). The shadows will then fall towards the opposite side (here it is on the bottom left).

3 Once those pebbles have dried, paint the remaining pebbles in the same way. For Pebble 2, use Mix 4 (purple-gray: see *Mixing your colors*). For Pebbles 4 and 6, use Mix 5 (blue-gray).

4 Once all the pebbles have dried, use a slightly darker mix of each color to add more shadow into each pebble on the lower left sides. Use a damp or dry brush to blend in a little. Using a dry brush here will help to add texture to the pebbles.

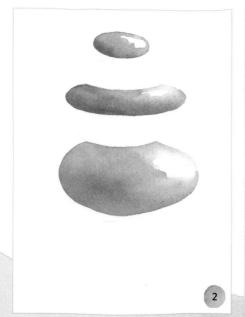

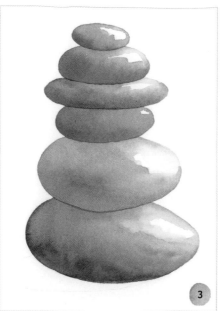

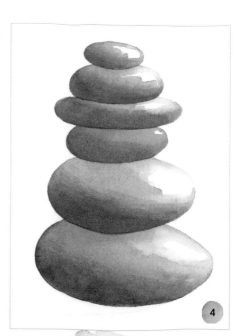

5 Using a much more concentrated version of each mix, paint in a shadow underneath each pebble with a size 2 brush. You can draw these in first if you want to. Remember that the sun is shining from the top right so the shadows will be more on the left. For each pebble start by painting the shadow on the right side where the pebbles meet, curving the shadow so that it is thicker on the left side. Underneath Pebble 3, make the shadow a similar width all the way across because Pebble 3 is larger than Pebble 4 so will be creating a more consistent shadow. All the shadows should have clean, crisp edges so do not blend them in.

6 For the finishing touches, use a size 0 round brush or smaller to paint in small dots and speckles across each pebble. Use Burnt Umber and Indigo for darker marks, then add some white marks with your opaque white paint. Once finished, why not pop it in a frame or clip it to your memo board to display your wonderful work!

Light and shadow

Direction of sunlight.

Add more shadow to the left side of the pebbles.

Start each shadow where the pebbles meet on the right side, increasing as you move left.

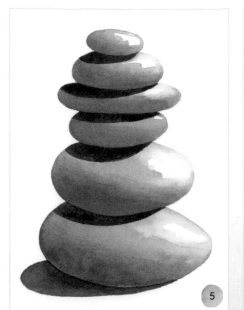

5

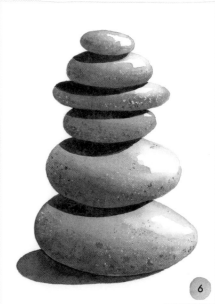

6

Log slice

There is so much inspiration to be found in nature.

There are so many interesting textures and details in subjects that can be found in nature, even something as seemingly simple as a log slice. These subjects can be recreated wonderfully with watercolor, transforming them into something so captivating on the paper. In this project, we will use the wet-on-wet technique to build up the initial layers of color, and then the wet-on-dry technique to create greater contrast and definition.

I love painting subjects that have a lot of texture in them, like wood and log slices. Not only are they really interesting to recreate but the process can also be very relaxing because of the repetitive nature of building up the layers and markings.

You will need

- Watercolor paper
- Water
- Paper towel
- Pencil & eraser (optional)

BRUSHES:

- Size 2 round brush
- Size 6 round brush
- Size 10 round brush
- Liner brush

PAINTS:

Yellow Ochre **Burnt Umber** **Indigo**

Mixing your colors

Add a little Indigo to Burnt Umber to make a darker brown. Be careful not to add too much as the Indigo will easily overwhelm the mix.

Mix 1

BU + In

PAINTING THE LOG SLICE

1 Prepare both your Yellow Ochre and Burnt Umber on your palette so they are ready for the wet-on-wet technique. This log is about 5½in (14cm) wide so we'll be using a size 10 round brush. Start by painting a slightly uneven circle with a diluted Yellow Ochre. If you wish to, you can draw this shape out first lightly in pencil. While it is still wet, move on to step 2. Leave enough space on the paper around the edge to add the bark later.

2 While the Yellow Ochre is still wet, pick up your Burnt Umber and drop some paint into the center. Then add more Burnt Umber in, painting in circles or curves from the center outwards. Leave to dry before moving onto the next step.

3 Make sure you have plenty of Burnt Umber on your palette, alongside Mix 1 (darker brown: see *Mixing your colors*). Using a round size 6 brush, paint the bark around the edge. Start with the Burnt Umber, and as you go along add in some of the darker brown mix to the edges so that it bleeds in. As you move around the edge, vary the mixes that you are using—adding more water for some lighter areas and switching between the browns, using the wet-on-wet technique to create soft blends between the values and colors. This contrast and variety will add texture. Make the edge rough with dabs of your brush and vary the thickness of the bark. On the bottom left, dip the bark in towards the circle—we will paint a crack here later on. Leave to dry.

The size of brush you need will be determined by the size of your painting. If you find you prefer working with smaller brushes, make your painting smaller, and vice versa.

4 Using your size 6 brush again, pick up some of your brown (either the Burnt Umber or dark brown—we will eventually use both) and dab it onto the paper towel a few times to take out the water. Use the side of your brush to paint a patchy dry brush effect into the main part of the log slice. Work around in a circular motion to cover a lot of the base, using the different brown mixes that you have already made on your palette. Leave to dry.

5 Load your liner brush with the dark brown mix and paint circles quite close together, starting from the center and working outwards. You may find it helpful to spin the paper around as you go. Remember, go slow and relax with your breathing. This part takes a little while! Use this time to really connect with your painting and feel calm.

6 For the final details, use a size 2 brush (or smaller) and a concentrated mix of the dark brown. Start by painting a small mark in the center of the log. Then paint a few larger cracks around the edges, followed by some finer lines, all directed towards the center. Using the same dark mix, add some final details to the edges of the bark by painting some small marks and wiggly lines to create texture in the bark.

I find a lot of the texture in nature fascinating to paint and recreate with watercolor. You can find more inspiration like this in wood, tree trunks, and bricks. Build up the layers with different values and colors, and then use more concentrated mixes to create contrast with smaller, darker marks.

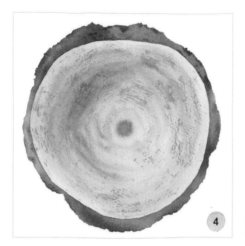

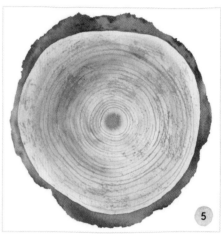

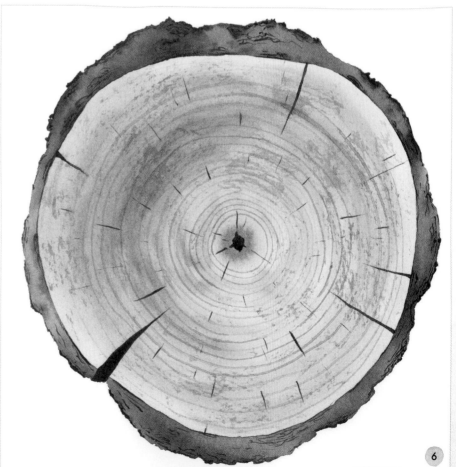

Citrus fruits

Citrus fruits are interesting and vibrant subjects, with repetitive features and markings that make them relaxing to paint. They are also a great, simple subject to practice watercolor techniques, from the wet-on-wet and variegated washes, to painting neat edges and finer details and marks.

You will need

- Watercolor paper
- Water
- Paper towel
- Pencil & eraser
- Masking fluid
- Shaper tool size 0 (or old brush to apply masking fluid)

BRUSHES:
- Size 0 round Brush
- Size 4 round Brush

PAINTS:

Permanent Rose Winsor Lemon Permanent Sap Green

Mixing your colors

We will be mixing three different oranges for this project. A brighter yellow-orange (Mix 1), made by adding just a little Permanent Rose to Winsor Lemon, a bolder orange (Mix 2) made by adding more Permanent Rose to Winsor Lemon, and a darker, more muted orange (Mix 3), made by adding a touch of Permanent Sap Green to Mix 2.

Mix 1
WL + PR

Mix 2
WL + PR

Mix 3
WL + PR + PSG

DRAWING THE CITRUS FRUIT

1 Draw the outline of the citrus fruit, starting with a circle. Don't worry about it being perfect, it will look more realistic if it is not completely even! In the center of the circle, draw a rough star shape. Then draw in the segments, leaving a thin gap between each one. Use your kneaded eraser to remove any excess pencil before you start painting.

ADDING MASKING FLUID

2 With your silicone shaper tool (or an old brush), add small dabs of masking fluid into each of the segments. Use quick dabbing motions so they vary in size. This will protect small patches of white paper for some highlights. Leave to dry completely before you start painting.

PAINTING THE CITRUS FRUIT

3 Prepare Mix 1 and Mix 2 (see ***Mixing your colors***). Using your size 4 brush, paint each segment one at a time, starting with Mix 1 (yellow-orange) on the inner half. While still wet, add Mix 2 (orange) into the outer half, overlapping the yellow-orange to create a graduated wash within each segment. Just by overlapping these colors they will naturally bleed into each other. Let the watercolor do the work here. Paint each segment in this way and then leave to dry.

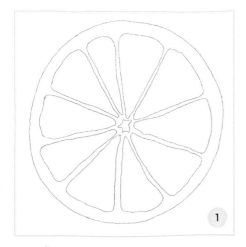
1

2

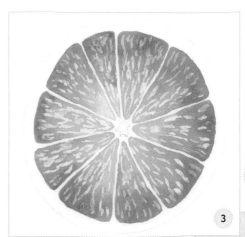
3

4 Once the paint is dry, use a concentrated Mix 2 (orange) to paint marks in each segment **(4a)** by pressing the brush down and lifting up.

5 Once all of the paint is completely dry, you can remove the masking fluid. Before you do, check that there is no paint pooling on top of the masking fluid so that you don't smudge this across the paper. If there is, remove it with your paper towel. To remove the masking fluid, gently rub with an eraser or with your thumb so that all of the white patches (highlights) are revealed.

6 Add some clean water around the edge of the fruit, just inside the circle. While that is still wet, use Mix 2 (orange) to paint a thin line around the outer edge, next to the wet area so that the color bleeds in. Once dry, paint another thin line around the edge to add more definition.

7 Add some final details using Mix 3 (muted orange: see *Mixing your colors*) and a size 0 brush. Paint around the edge of the star shape in the center and then use a clean wet brush to blend the color into the middle so it's a bit lighter. Add some small marks to the segments to add a bit of contrast, separating any larger white highlights that the masking fluid created. You can also add some small dots around the edge of the orange using the tip of the brush to add a bit of texture.

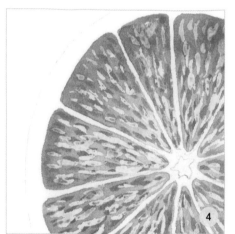

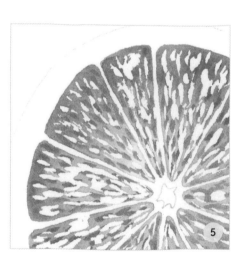

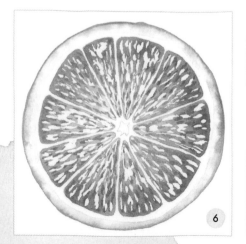

If you prefer not to use masking fluid, you can add the highlights at the end with opaque white paint or a white pen instead.

More inspiration

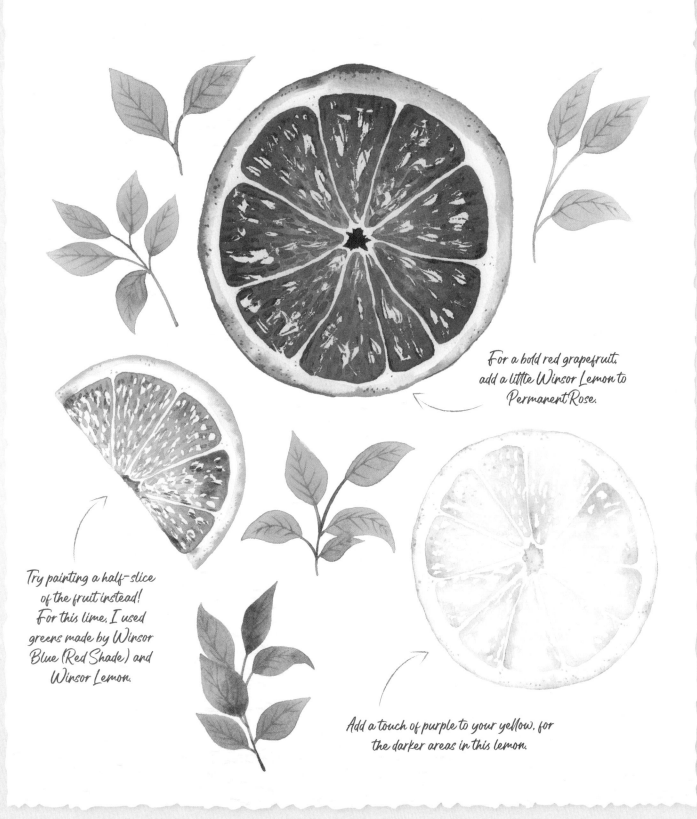

For a bold red grapefruit, add a little Winsor Lemon to Permanent Rose.

Try painting a half-slice of the fruit instead! For this lime, I used greens made by Winsor Blue (Red Shade) and Winsor Lemon.

Add a touch of purple to your yellow, for the darker areas in this lemon.

Gemstones

Gemstones have a beautiful range of colors and values within them. The painting process is incredibly relaxing, simply filling in each section using the wet-on-wet technique. It is another subject that you can replicate using different colors and shapes! Before you begin, trace the full-sized template provided.

You will need

- Watercolor paper
- Water
- Paper towel
- Pencil & eraser
- Ruler
- Tracing paper or light pad
- Opaque white paint or gel pen

BRUSHES:

- Size 2 round brush
- Size 4 round brush

PAINTS:

Winsor Blue (Red Shade) Winsor Lemon Indigo

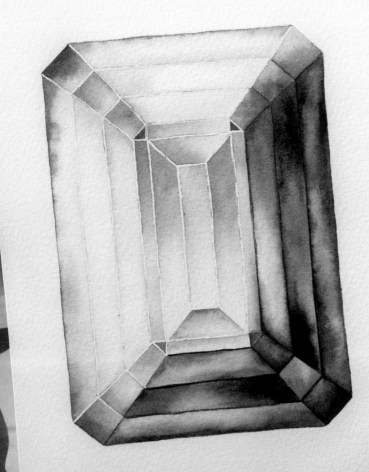

Mixing your colors

Create subtle variations of blues to give the illusion of a glassy surface within the gemstone. Use either Indigo or Winsor Blue (Red Shade) on their own, or add a little Winsor Lemon to the Winsor Blue. Mixes 1 and 2 have slightly different quantities of the yellow added to them.

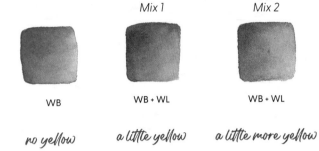

Mix 1 Mix 2

WB WB + WL WB + WL

no yellow *a little yellow* *a little more yellow*

TEMPLATE

You can download a printable version of this template from:
www.davidandcharles.com

PAINTING THE GEMSTONE

1 Once you have traced the template, prepare your blue mixes (see *Mixing your colors*). We will paint the middle, left and top sections lighter than the rest to give the illusion of the sunlight coming from the left, upper side. Using a size 4 round brush, paint the sections shown. For each section, start by adding clean water, or a diluted mix to the center, then add a slightly darker mix to the edges so that it blends in.

1

2 Once the painted sections are dry, fill in the remaining sections in the middle, left and top in the same way. Start with the sections on the left and right of the middle rectangle. Then fill in the small triangular corners in a slightly more concentrated blue to provide a bit of contrast to the rest. Continue to fill in every other section.

3 Once the center sections have dried, you can fill in the remaining sections around the center. Then fill in every other section on the right and bottom sides using more concentrated versions of Indigo, Winsor Blue (Red Shade) or Mixes 1 and 2.

4 Once dried, fill in the remaining sections using Indigo or more concentrated versions of Winsor Blue (Red Shade) or Mixes 1 and 2.

5 Once everything has dried, use your size 2 round brush to paint thin lines between each section to create more of a contrast. Use opaque white for the middle, left and top lines, and Indigo for the bottom and right side where it is darker.

Within each section, experiment with wet-on-wet and try out subtle variations of colors. This will add to the final effect of the gemstone by creating more reflections and making it seem more realistic.

More inspiration

Try more gemstones in different shapes and colors! Experiment with hearts, circles, ovals, squares and more. Draw the outline of your shape first and then divide it into symmetrical shapes inside, using a ruler. Once you have designed the shape and broken it down into sections, keep it as a template so you can trace it again and try out more colors.

Combine reds and blacks for a bold ruby-like heart-shaped gemstone.

Mix greens and blue-greens to create a calming pear-shaped gemstone.

Try softer pinks and purples in a rounded square.

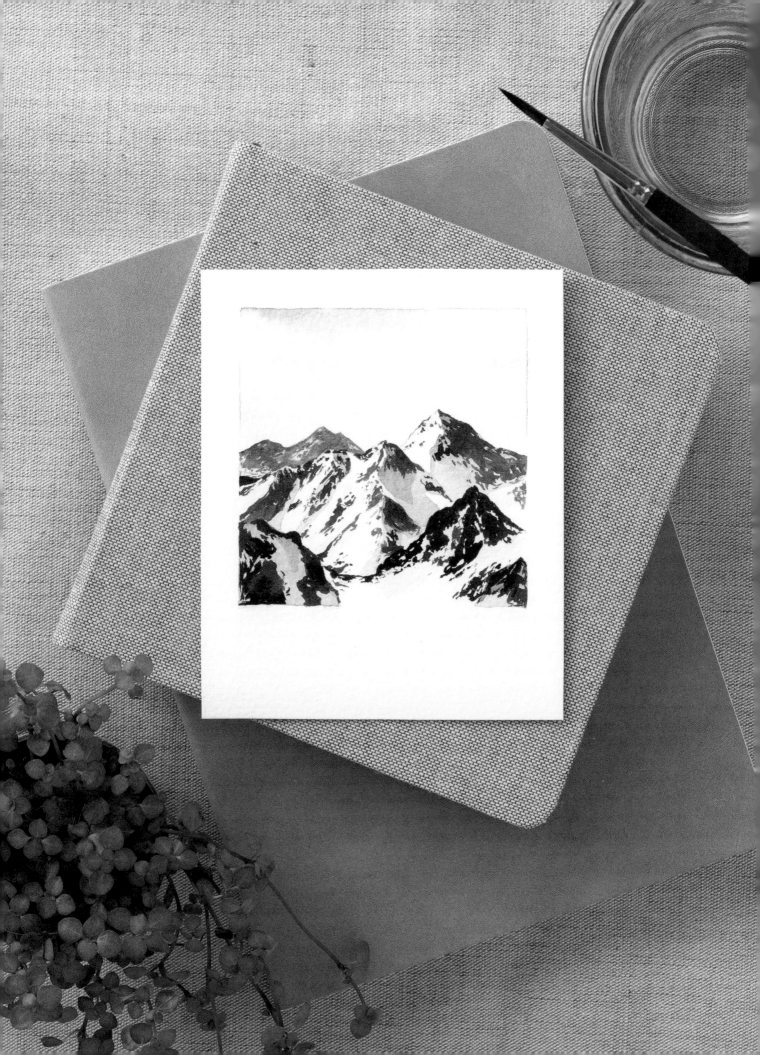

Snowy mountains

I love these snowy mountains because they look so serene. When it's not always possible to see views like this in real life, painting simple landscapes can make you feel closer to nature. They are also surprisingly easy to paint! Painting small pieces within a polaroid can also be fun and feel less daunting than trying to tackle a larger, more complicated piece.

I love painting mini landscapes that you feel like you can step into.

You will need

- Watercolor paper
- Water
- Paper towel
- Pencil & eraser
- Ruler
- Masking tape (optional)

BRUSHES:
- Size 4 round brush

PAINTS:

Indigo Burnt Umber

Mixing your colors

Add a little Indigo to Burnt Umber to make a dark brown. Be careful not to add too much Indigo as it will easily overwhelm the mix.

Mix 1

BU + In

DRAWING THE SCENE

1 For the polaroid, draw a rectangle 4in (10cm) wide by 4¾in (12cm) high. Then draw a square inside the rectangle that is 3¼ x 3¼in (8 x 8cm). The borders at the left, top and right should be ⅜in (1cm) with a wider border at the bottom of 1⅛in (3cm). Next, draw the outline of the mountains as shown. Make sure there are three sections of mountains for the foreground, midground and background as this will help create the illusion of distance. Lighten the pencil lines by pressing your kneaded eraser against the paper. You can add masking tape around the edge of the square for a neat border.

PAINTING THE SCENE

2 For the cloudy sky, add some clean water to the paper above the mountains with a size 4 round brush. While still wet, add some diluted Indigo onto the paper in horizontal strokes, leaving some white gaps for clouds. Work carefully around the edge of the mountains. We want this to be subtle so it doesn't distract from the main feature of the mountains so be careful not to add too much color. If you need to, you can use your paper towel or your brush to lift some of the paint for the clouds.

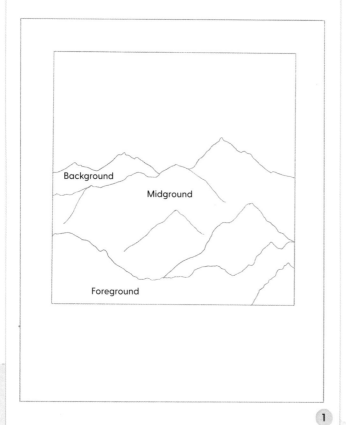

3 Using the diluted Indigo again, paint the first layer of shadows across the mountains, leaving plenty of white space for the snow. Try to keep the shadows consistent by placing them on the right side of any mountain peaks. Leave to dry.

4 Using a slightly more concentrated Indigo, add some darker shadows at the top of each of the mountains. Add some small patches of shadow with a very diluted Indigo on the left side of some of the mountains as well.

5 Dilute Mix 1 (dark brown) a little to add some dark brown patches to the mountain in the background. In some areas, leave some gaps for the pale blue to show through by painting small marks with your brush. This diluted brown will look further away when placed next to the more concentrated brown that we will paint in the next steps.

6 Using a more concentrated Mix 1, paint in the rocks in the midground using dabbing motions to create different sized marks and dots. Concentrate the brown more on the right-hand side of the mountains in the shadows, with a few smaller rocks scattered on the left-hand sides in the white areas.

7 Using the most concentrated mix of brown that you can make, paint the rocks in the foreground. When finished and your paint has dried, remove the masking tape and any remaining pencil lines around the edge.

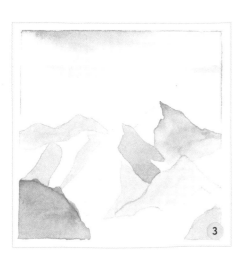

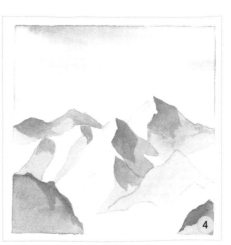

When painting landscapes, think of the painting in three areas: the background, midground and foreground. This will add a sense of depth to your painting.

Feathers

Feathers are a lovely subject for painting in watercolor and turning into a piece of wall art, a gift, or a greeting card. Within a few simple steps, you can create something quite beautiful. You can make these your own and paint endless varieties from your imagination, varying the colors and details!

You will need

- Watercolor paper
- Water
- Paper towel
- Pencil & eraser
- Opaque white paint or gel pen

BRUSHES:

- Size 2 round brush
- Size 6 round brush
- Liner brush

PAINTS:

Permanent Rose

Winsor Blue (Red Shade)

Winsor Lemon

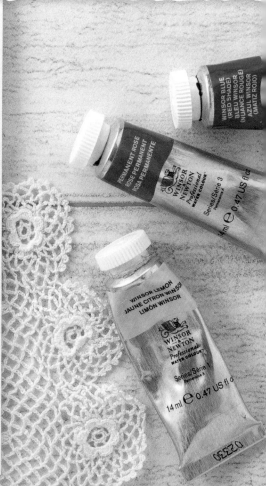

Mixing your colors

For the pink-purple (Mix 1), add some Winsor Blue (Red Shade) to Permanent Rose. We will be using different values of this mix for the lighter and darker areas of the feather. For the gray of the spine (Mix 2), mix Winsor Blue (Red Shade) and Permanent Rose to make a purple, and then add a little Winsor Lemon to turn it into gray. Alternatively, you can use a pre-mixed color like Payne's Gray for convenience.

Mix 1

PR + WB

Mix 2

WB + PR + WL

DRAWING THE FEATHER

1 Lightly draw the outline of the feather, starting with a curved line for the spine. Add a second line parallel to it, coming to a point as you reach the top. Next, draw the outline of the feather's hairs. Start from about a third of the way up the spine and draw a curve that reaches to a soft point and comes back down the other side. This is only a guide for the overall shape of the feather and we will erase this later so make sure it is light.

PAINTING THE FEATHER

2 Prepare diluted and concentrated versions of Mix 1 (pink-purple: see *Mixing your colors*). Using a size 6 brush, lay down some clean water inside the outline of the feather, avoiding the edges. Add a diluted Mix 1 at the inner edge so that it bleeds into the wet area. Create a jagged outer edge using a more concentrated Mix 1 to suggest lots of hairs. Add more color around the edges as you need to.

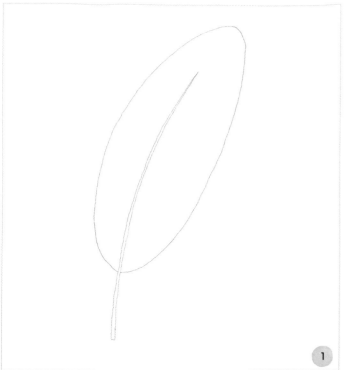

1

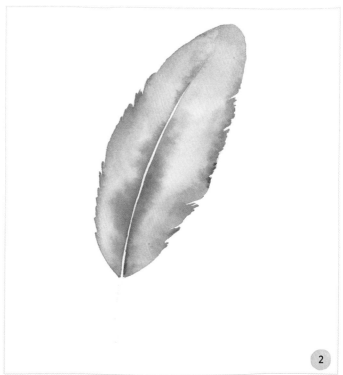

2

3 Using a size 2 brush and a diluted Mix 1, add very pale wiggly lines at the base of the feather.

4 Using your liner brush, or smallest brush, with a more concentrated Mix 1, paint fine lines inwards from the outer edges. Add some shorter lines going outwards from the inner edge as well. Vary the length and gaps between these lines so that they are not too consistent or uniform. Use this step as an opportunity to neaten up the outer edge, adding definition to the jagged edges. Darken the edges of the spine as well to make it stand out more.

5 Continuing with this more concentrated Mix 1, add darker wiggly lines on top of the lighter ones at the base of the feather. The lighter lines should be dry so that these darker lines on top are crisp. Using a size 2 brush and Mix 2 (gray: see *Mixing your colors*), paint the edges of the spine and then use a damp brush to soften in the middle, leaving a bit of white for a highlight. Lift the paint in the middle with your brush if you need to.

6 For the final details, use an opaque white gel pen (or paint) to add some white dots randomly over the feather.

3

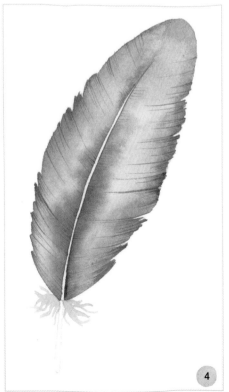

4

5

6

More inspiration

Feathers are such a fun topic to paint! Just like the butterflies, once you know the basic shape you can choose your own colors and details to make up your own styles. Try blending multiple colors together or adding different markings and details.

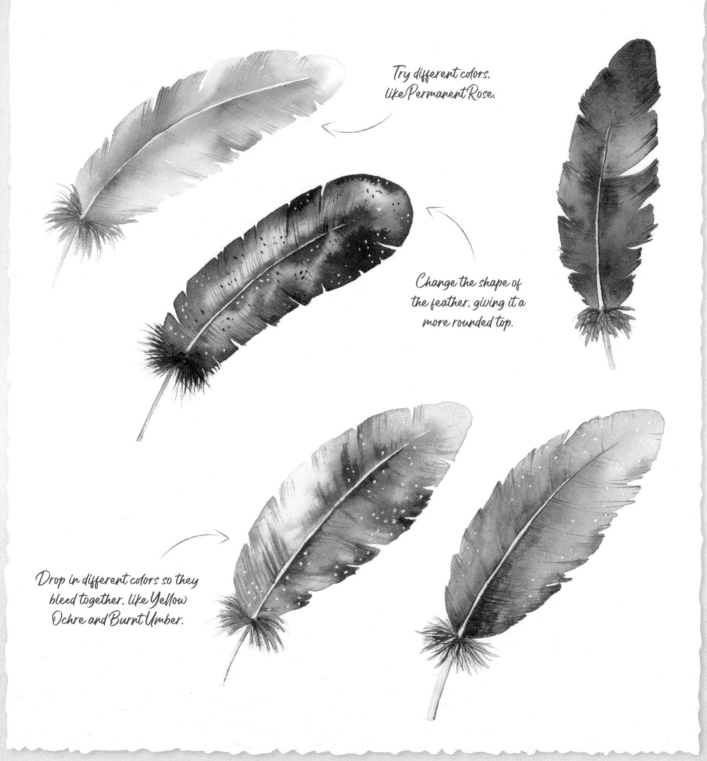

Try different colors, like Permanent Rose.

Change the shape of the feather, giving it a more rounded top.

Drop in different colors so they bleed together, like Yellow Ochre and Burnt Umber.

Echinacea

Echinaceas, also known as Coneflowers, are one of my favorite flowers. The contrast between the vibrant central cone and the delicate petals makes them so attractive to look at and so interesting to paint! I always find flowers calming to paint as they make me feel closer to nature. Paint this flower just for fun or turn it into a beautiful card for friends or family.

You will need

· Watercolor paper 9½ x 4¾in (24 x 12cm)
· Water
· Paper towel
· Pencil & eraser

FOR THE GREETING CARD (OPTIONAL):

· Ruler
· Scissors or cutting tool
· Bone folder tool
· Sheet of regular paper (for splatters)

BRUSHES:

· Size 2 round brush
· Liner brush
· Flat shader size 2

PAINTS:

Winsor Lemon	Permanent Rose	Winsor Blue (Red Shade)

Burnt Umber	Indigo

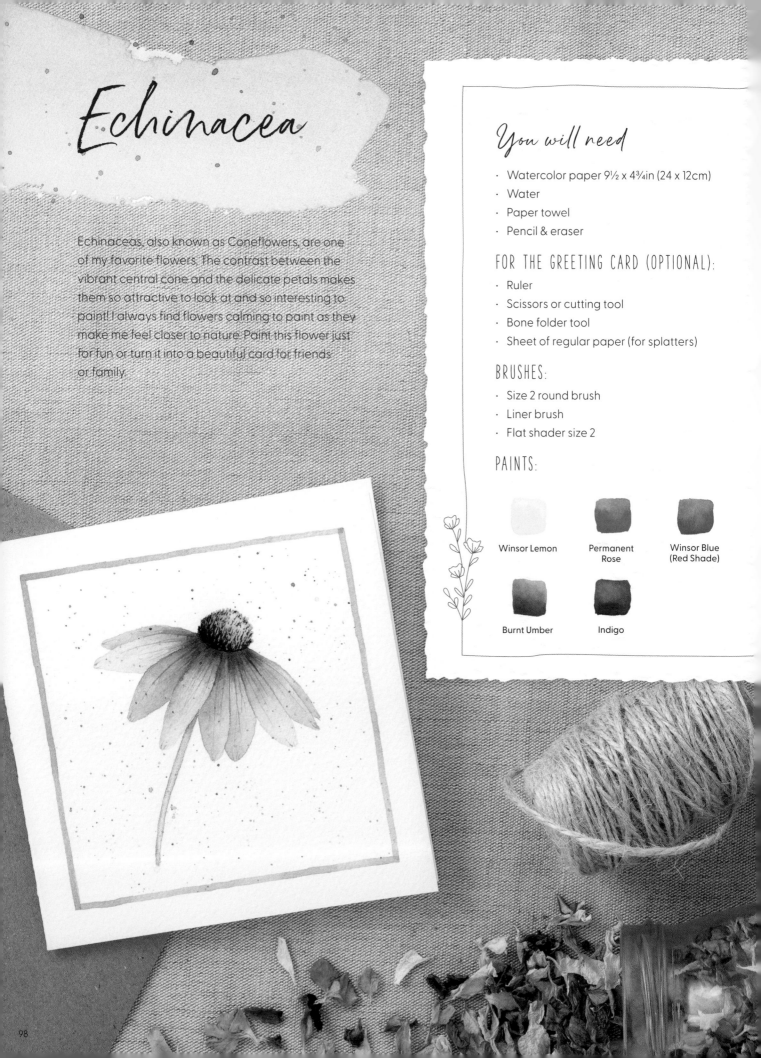

Mixing your colors

For the cone, make an orange using Winsor Lemon and Permanent Rose (Mix 1), followed by a red-orange with more Permanent Rose in the mix (Mix 2). For the marks on the head mix a dark brown with Burnt Umber and Indigo (Mix 4).

For the petals, make a pinky-purple by adding a little Winsor Blue (Red Shade) to Permanent Rose (Mix 3).

For the stem, make a warm, muted green by mixing Winsor Lemon and Winsor Blue (Red Shade) together and then adding a touch of Permanent Rose (Mix 5).

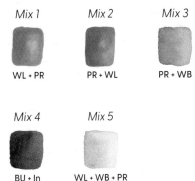

Mix 1 — WL + PR

Mix 2 — PR + WL

Mix 3 — PR + WB

Mix 4 — BU + In

Mix 5 — WL + WB + PR

PREPARING THE CARD

1 For the outline of the card, draw a rectangle 9½in (24cm) wide by 4¾in (12cm) high. Very lightly, draw the central line where the card will be folded. On the right-hand side, lightly draw a square of 4in (10cm) for a border, ⅜in (1cm) in from each edge.

DRAWING THE ECHINACEA

2 For the flower, start with a semi-circle for the cone head, with a curved base. Draw in the petals, widening out slightly in the middle of each one and coming to a jagged point at the end. Finally, draw in the stem slightly curving down. Lighten the pencil with your kneaded eraser before you start painting.

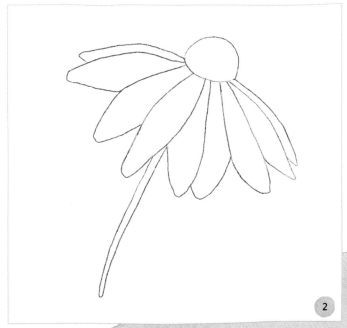

PAINTING THE ECHINACEA

3 Using the wet-on-wet technique and a size 2 brush, paint the cone head. Prepare Mix 1 (orange: see *Mixing your colors*), Mix 2 (red-orange), and Burnt Umber on your palette before you start painting. Begin with a diluted Mix 1 covering the whole cone, adding small spikes coming out of the edge. While still wet, add a more concentrated Mix 2 on the lower left, leaving the orange to shine through in the top right corner. Add Burnt Umber at the bottom and left. The color should blend gradually from brown to paler orange.

4 Still using a size 2 brush, paint every other petal, one at a time using the wet-on-wet technique. Start with a very diluted Mix 3 (pink-purple: see *Mixing your colors*) and then add a more concentrated Mix 3 to the top of each petal, directly underneath the head, so that it blends in to the paler color. This will act as a shadow. Clean and dry your brush to blend in more if you need to.

5 Once the petals from step 4 have dried, paint in the remaining petals with the same method. Add some more concentrated Mix 3 across all the petals underneath the cone head and blend it in with a damp brush. Next, use Mix 4 (dark brown: see *Mixing your colors*) to paint small dash marks all over the cone. Make them slightly bigger and closer together at the bottom and left side to give the cone dimension.

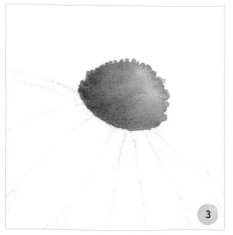

3

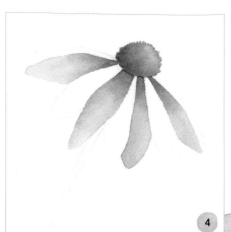

4

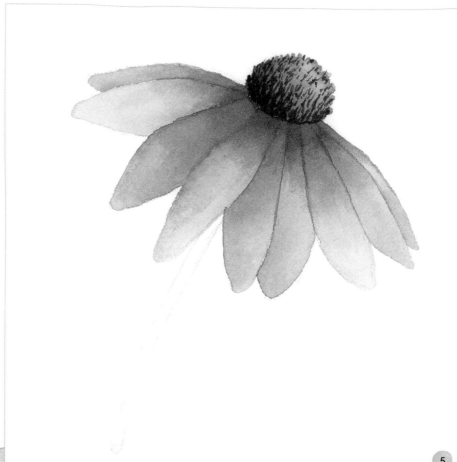

5

FINISHING THE CARD

6 Use a liner brush and Mix 3 (pink-purple) to paint fine lines down each of the petals, with shorter dashes at the end of each petal. With a diluted Mix 3 you can also add some small marks along the petals for extra texture. For the stem, use a size 2 brush and Mix 5 (warm, muted green). Paint the edges first and then use a damp brush to blend into the centre, adding a little more color at the top, just underneath the petals, for a slight shadow.

7 Using your flat shader, paint the border with the pink-purple Mix 3, just inside of the pencil line that we drew in step 1. Then cut a 4in (10cm) square window in the center of a piece of regular paper. Place the window over the card leaving only the flower and border visible. The rest of the card will be masked to protect it. Now, add green and pink splatters by tapping your brush on top of another brush. Leave to dry and then remove any remaining pencil lines with your kneaded eraser.

A bone folding tool is really useful for folding paper if you like to make cards like this regularly. Alternatively, re-draw the midway pencil line on the opposite side of the paper and then use a ruler to carefully bend the paper against. Then gently press down on the fold to flatten it.

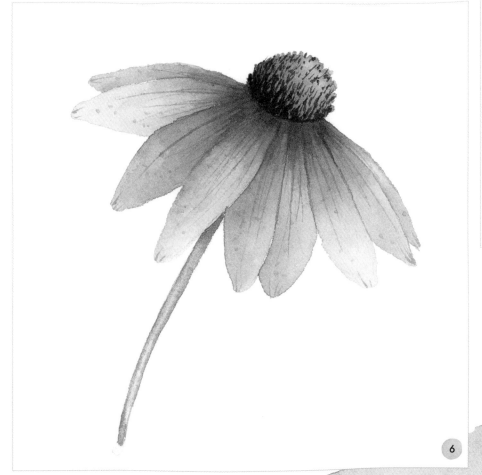

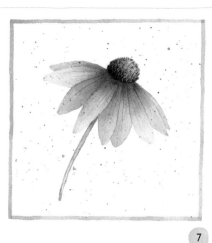

*Head to **Techniques: Paint Splatters** to learn more about adding splatters like this to your painting!*

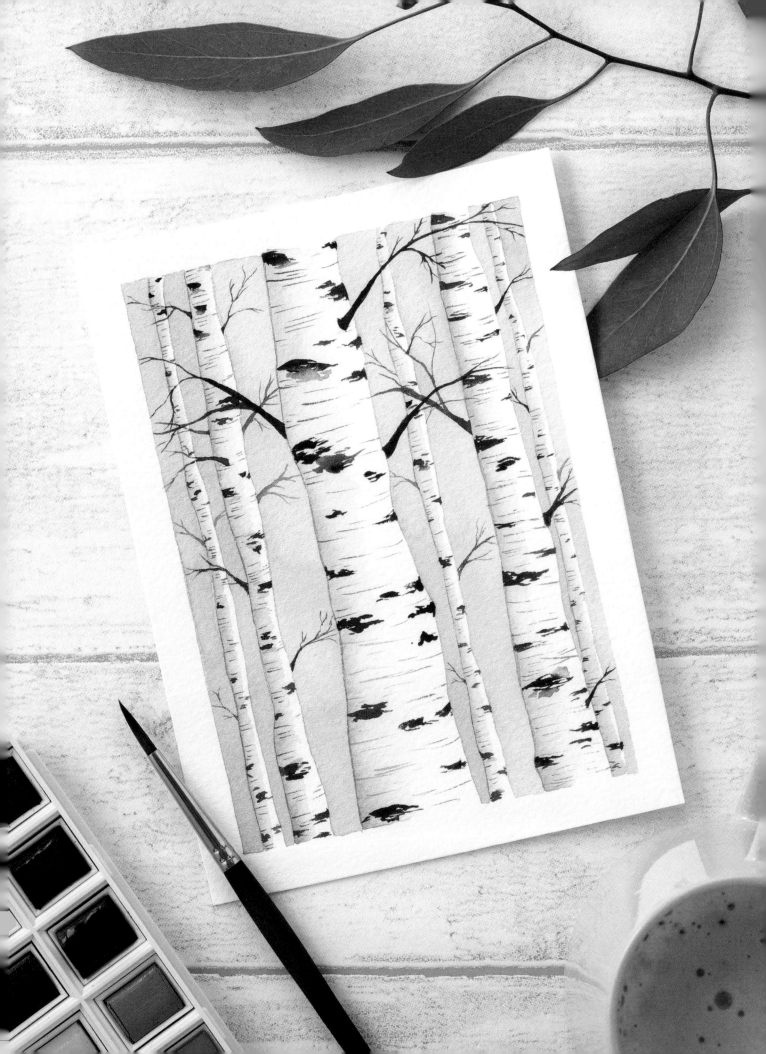

Birch trees

Birch trees are so distinctive and recognizable, with the interesting texture and markings on the bark. Creating a simple composition with multiple tree trunks like this is not only calming to look at but also relaxing to paint with the repetitive nature of the details.

Painting simple scenes can be really calming.

You will need

- Watercolor paper
- Water
- Paper towel
- Pencil & eraser
- Ruler
- Scissors or cutting tool
- Masking tape (optional)

BRUSHES:

- Size 2 round brush
- Size 4 round brush

PAINTS:

Indigo

Winsor Lemon

Permanent Rose

Burnt Umber

Mixing your colors

For the blue-gray of the trunks (Mix 1), add a little Winsor Lemon and Permanent Rose to Indigo. For the dark brown details on the trunks (Mix 2), add a little Indigo to Burnt Umber for a dark brown. Be careful not to add to much as the Indigo will easily overwhelm the mix.

Mix 1

Mix 2

In + WL + PR

BU + In

DRAWING THE TREES

1 Draw a rectangle, 4¾in (12cm) wide by (6¼in (16cm) high, for the outside edge, which you can later cut around. Within this, draw a second rectangle ⅜in (1cm) smaller all the way around, 4in (10cm) wide by 5½in (14cm). Draw the outline of six trees. Start with the widest one in the center, then draw two thinner ones on the left and three more on the right. Don't make the lines too straight. Birch trees are naturally a little uneven. For the trunk on the far right, place this slightly behind the one next to it on its left. If you wish to, you can place masking tape around the border to keep the edges neat.

PAINTING THE TREES

2 Using a size 4 round brush and Mix 1 (blue-gray), paint a shadow on the left side of each tree, one by one. Wash the paint from your brush and use a damp brush to soften the edges so the color gets lighter towards the center of each tree. You may find it easiest to paint half a tree at a time, soften the edge and then continue painting the rest of that tree. Leave the right half of each tree white for a contrast. Leave to dry before moving on to the next step.

3 Using a size 2 round brush and Mix 2 (dark brown), paint in markings across each tree. Vary the pressure of the brush to get different sized marks **(3a)**. You can wash the paint from your brush and add a little water underneath some of them to create some transitions to lighter marks as well.

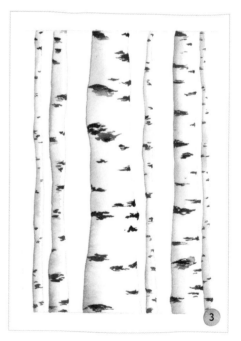

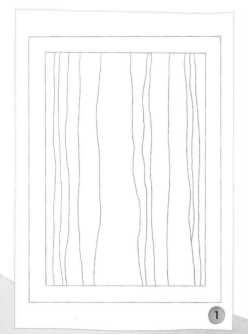

4 Using the same dark brown mix and a size 2 brush, paint fine horizontal lines across each tree. Vary the length and the gaps between them all so that they do not appear too consistent or uniform. Remember to take the excess water out of your brush so that these lines are nice and fine.

5 With a diluted Indigo and a size 4 brush, paint the gaps in between each tree with a flat wash for the sky. Go slow around the edges to keep it neat.

For flat washes like this, remember to prepare plenty of paint beforehand to achieve an even color. Work from top to bottom for a smooth finish.

6 Once the sky is dry, paint branches coming out of each tree using the dark brown mix. The wider trees are closer than the thinner trees, so any branches that come from them will overlap the thinner trees and they will also be thicker. Branches from the thinner trees will go behind the wider trees. This will help give the painting some perspective. If you need to, draw these in first so you don't need to worry about making a mistake. When you are finished and the paint is dry, remove any remaining pencil lines with your eraser.

Reeds at sunset

I find these simple, yet beautiful, landscapes both calming to paint and to look at. Painting skies using different washes, combined with fine details for silhouettes, gives you the ability to create so many different versions of these. Make them into bookmarks for you to see and enjoy around the home!

You will need

- Watercolor paper
- Water
- Paper towel
- Pencil & eraser
- Ruler
- Masking tape
- Scissors or cutting tool

BRUSHES:

- Size 0 round brush
- Size 2 round brush
- Size 8 round brush
- Liner brush

PAINTS:

Winsor Lemon Permanent Rose Payne's Gray

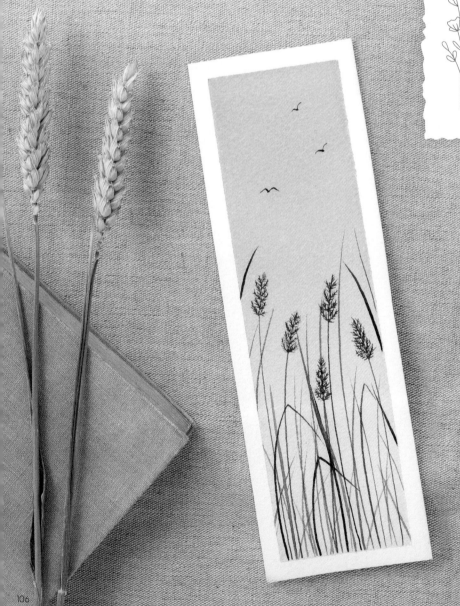

PREPARING THE BOOKMARK

1 Start by drawing and cutting out your bookmark, 2¼in (6cm) wide by 7in (18cm) high. Mark a ¼in (5mm) border around the edges and place masking tape up to the lines to protect the border.

Mixing your colors

Mix Permanent Rose and Winsor Lemon together for an orange to add into the middle of the variegated wash for the sunset.

Mix 1

WL + PR

PAINTING THE SUNSET

2 For the sunset sky, we will use the wet-on-wet technique so prepare the Winsor Lemon, Permanent Rose and Mix 1 (orange: see **Mixing your colors**) on your palette. With a size 8 round brush, lay clean water down evenly across the paper. Tilt the paper so that any excess water runs to the bottom and remove this before you add any paint.

Start with a diluted yellow at one end, using horizontal strokes and painting about three-quarters of the way down the paper. Add the diluted orange mix in the middle, in horizontal strokes blending it in with the yellow. Add the diluted Permanent Rose at the opposite end to the yellow, using horizontal strokes again blending it in with the orange. To blend the colors more, load your brush with the diluted pink and run it all the way from the top (where the pink already is) to the bottom so that all the colors blend smoothly together. Leave to dry completely before painting the reeds.

1

2

*Head to **Techniques: Variegated Washes** for more tips on painting smooth washes like this.*

PAINTING THE REEDS

3 Using a liner brush and a concentrated Payne's Gray, paint five slightly curved lines for the reeds at different heights, with the highest going just above the halfway point **(3a)**. With a size 0 brush, paint short diagonal lines at the top of each reed, as shown in the example **(3b)**, then add smaller lines either side of these. For these delicate fine lines, make sure you remove the excess water out of your brush to give you more control.

4 Switch to a size 2 brush to paint some grass. Use long, flicking strokes so that they taper to a point at the end. Vary the length of these blades of grass, with some reaching slightly higher than the reeds. Paint a few blades bending over by sharply changing the angle of the brush and flicking the stroke downwards.

5 To finish, add three birds in the sky. For each bird paint two adjoining curves using your size 0 brush, adding a little thickness in the center.

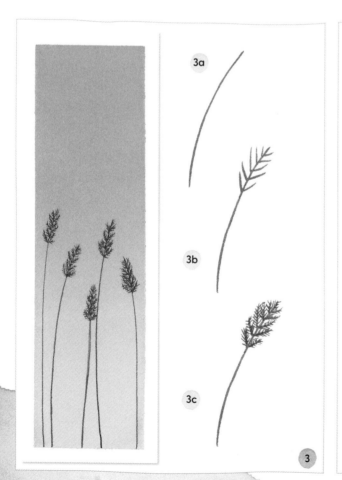

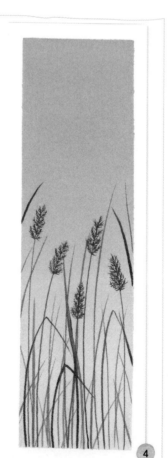

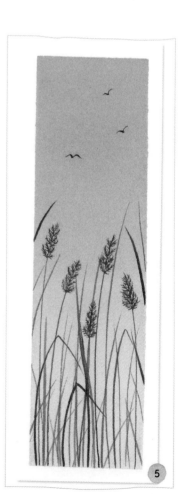

More inspiration

There are an infinite number of combinations that you could try for painting simple skies and silhouettes like this. For the backgrounds, try using flat, graduated, or variegated washes (see *Techniques: Washes* for more details), or drop color onto a wet surface to create some soft blends and to suggest clouds. Experiment with different color combinations—blues and greens, or pinks and purples. Then add different details for the silhouettes from birds and reeds, to mountains, trees, boats, and more! There is no reason for you to run out of inspiration on what to paint if you enjoy topics like these.

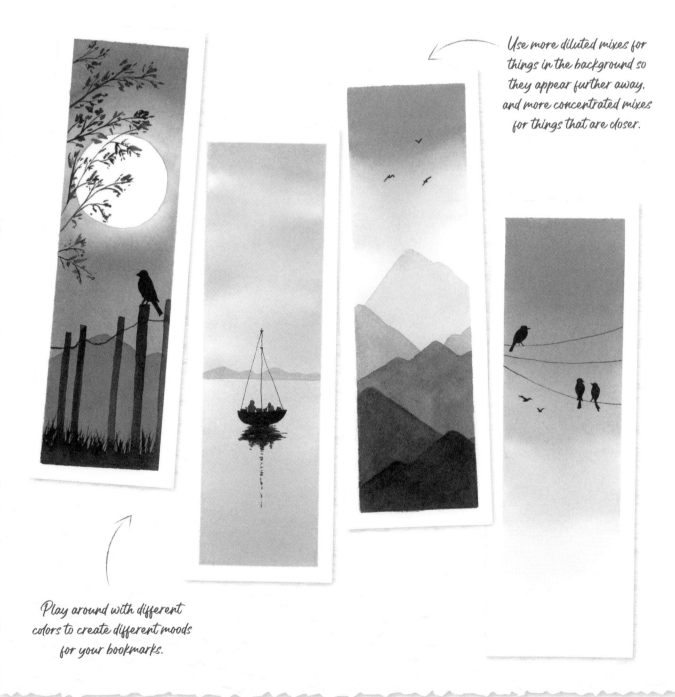

Use more diluted mixes for things in the background so they appear further away, and more concentrated mixes for things that are closer.

Play around with different colors to create different moods for your bookmarks.

Butterflies

Butterflies can be really joyful to paint, with their delicate frames and beautiful patterns. By building up the layers from the soft blends of wet-on-wet to the crisp markings of wet-on-dry, you can create a striking contrast between the two effects. I love subjects like this where you can paint pages and pages of different versions knowing that there will always be more combinations of colors and patterns to explore!

You will need

- Watercolor paper
- Water
- Paper towel
- Pencil & eraser

BRUSHES:

- Size 2 round brush
- Size 6 round brush
- Liner brush or your smallest round brush

PAINTS:

 Permanent Rose

 Permanent Sap Green

 Burnt Umber

 Indigo

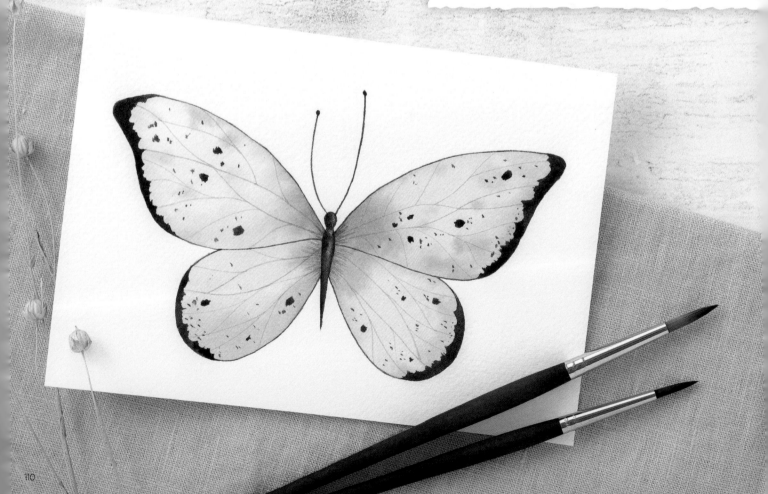

Mixing your colors

We will be using the wet-on-wet technique for the first layer in step 2, so prepare your paint on your palette before you start. This dusky pink mix is made by adding a touch of Permanent Sap Green to Permanent Rose. Be careful not to add too much green as it will easily overwhelm the pink.

For the dark brown mix in steps 3-6, add a little Indigo to Burnt Umber. This will make the pre-mixed brown darker, giving the final details more of a contrast.

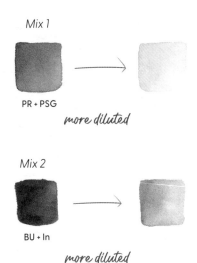

Mix 1

PR + PSG

more diluted

Mix 2

BU + In

more diluted

DRAWING THE BUTTERFLY

1 To draw the outline, start with the body in the center—draw a small circle for the head and add a narrow body, thinning to a point at the bottom. Next, draw the top wings. Try to keep everything fairly symmetrical. Finally, draw the bottom wings in, making them slightly narrower and rounder than the top two.

PAINTING THE BUTTERFLY

2 As we'll be using the wet-on-wet technique (see *Techniques: Methods of Applying Paint* for more on this), I recommend painting one wing at a time to avoid them drying before you add more color. For the first layer, start with a very diluted Mix 1 (pink—see *Mixing your colors*) and your size 6 round brush. While it is still wet, add a more concentrated mix to the areas near the body and to the outer edges of the wings. Add in some dabs of paint in the center of the wings for lighter markings.

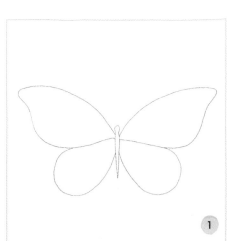

1

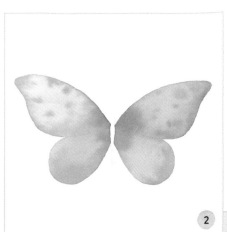

2

Use a damp brush to encourage movement where you need to, and a dry brush to pick up any excess water that is pooling on the paper.

3 Once the wings have dried, paint the head and body using the dark brown mix with your size 2 brush. To add dimension, dry your brush on some paper towel and use it to lift some paint from the right side of the body for a highlight. If you need to, add more paint to the left side. Finish the body with two antennae at the top of the head, painting thin curved lines with a small circle at the top of each one.

4 Using the same dark brown mix, paint a fine outline around each wing, and then paint the edges of the wings with a rough scalloped pattern—use the tip of the brush to paint the outline of the scalloped edge and then

fill it in. This concentrated color mix for the markings will create a striking contrast against the soft background of the pink wings.

5 With your liner brush (or smallest round brush) and a diluted version of the dark-brown mix, paint some fine lines over each wing, starting from the inner edge and curving around with the shape of the wing. To get nice fine lines, remember to take the excess water out of your brush before you start painting and rest your hand on the table to keep it steady.

6 For the final details, return to the more concentrated dark brown mix and your size 2 brush. You don't need to worry about these marks being symmetrical. Start with a few short flicking strokes from the center of the wings to add a bit more depth there (see *Techniques: Brush Strokes* for more on this motion). Then add some markings on the wings—I've used a few larger marks on each wing surrounded by lots of small dots.

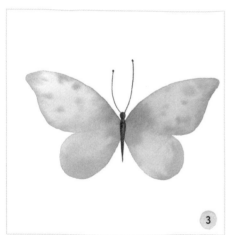

Instead of lifting away paint, you can add the highlight into the body using opaque white paint or a white gel pen.

More inspiration

Play around with different shapes and sizes for the wings, including scalloped edges.

Try decorating with different patterns, mixing lines, dots, and other markings.

Use diluted washes and blends to create a more subtle, delicate effect.

Add some white details with opaque white paint or a gel pen.

Create contrast by using bold colors.

CREATIVE DESIGNS

Let go of the idea that what you paint has to be true to life. Of course, it can be fun to paint something realistically from a reference photo, but you can also give yourself permission to paint more freely from your imagination. Once you get to know the defining features of a subject, for example the shape of the wings of a butterfly, play around with your own details within that, making them as simple or as detailed as you like.

Maidenhair fern

There are so many beautiful varieties of ferns to paint, focusing on the gorgeous greens in the leaves. The maidenhair fern, with its repetitive elements, is perfect for a good, mindful session of painting. This project will take a little while, so put on some nice music, relax, and enjoy the process. Don't rush it!

I recommend starting at the top, working your way down, leaf by leaf. You can place a paper towel underneath your hand so you don't smudge the pencil lines or mark the paper.

You will need

- Watercolor paper
- Water
- Paper towel
- Pencil & eraser

BRUSHES:

- Size 2 round brush
- Liner brush

PAINTS:

Permanent Sap Green · Yellow Ochre · Burnt Umber · Indigo

Mixing your colors

Add a little Yellow Ochre to Permanent Sap Green to make a warm, muted green for the leaves (Mix 1). Add some Indigo to Burnt Umber to make a dark brown for the stem and branches (Mix 2).

Mix 1
PSG + YO

Mix 2
BU + In

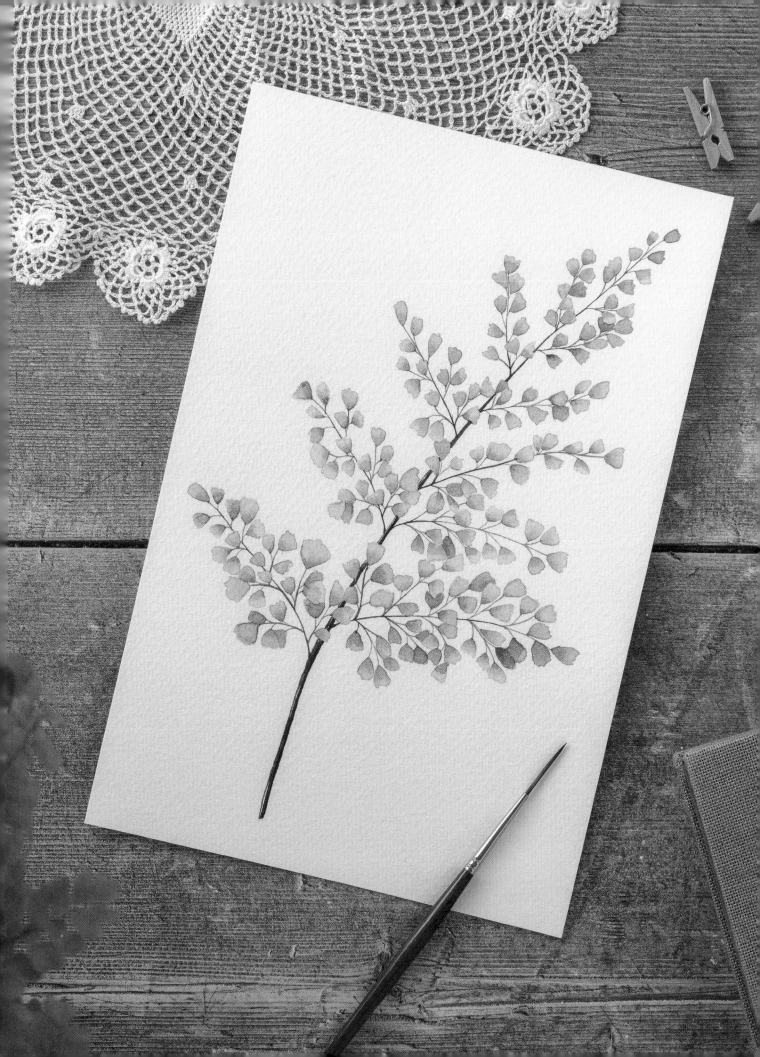

DRAWING THE FERN

1 Start by drawing the outline of the fern. First, lightly draw a curved line for the main stem. Draw another line parallel to this to make the stem slightly thicker, becoming narrower towards the top. Add curved lines on either side for branches, becoming shorter towards the top.

2 Add more curved lines to either side of each branch, becoming shorter towards the end of each branch **(2a)**. Next, add even smaller lines growing from each line you just added **(2b)**.

3 At the end of each stem, draw a leaf **(3a)**. These will start at a point, curving around with an almost flat, jagged edge at the top **(3b)**. Some of the leaves will naturally overlap the stems or other leaves **(3c)**. Erase any extra lines before you start painting so that you know which leaves sit underneath and which ones sit on top.

If this fern looks too time consuming for you right now, you can easily simplify it by reducing the number of leaves and making them larger.

1

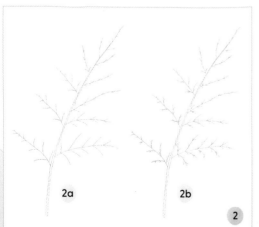

2a 2b

2

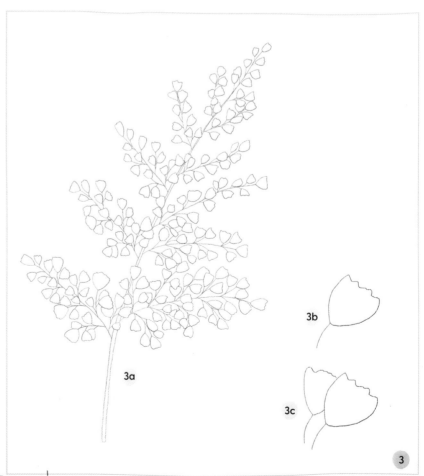

3a

3b

3c

3

PAINTING THE FERN

4 Now you have your outline, you can paint the leaves using the wet-on-wet technique and your size 2 round brush. Prepare Mix 1 (warm, muted green—see *Mixing your colors*) on your palette, with a separate area for the Permanent Sap Green on its own. Paint each leaf with a diluted Mix 1 **(4a)** and then add a little concentrated Permanent Sap Green to the base while still wet so it bleeds in **(4b)**. For the leaves that are overlapping, paint these as normal and then when they are dry, darken the leaf that is underneath to separate them **(4c)**.

5 With your liner brush, or a small round brush, paint the stems. Start with your Burnt Umber, painting the more delicate stems that are towards the ends of each branch. Then using Mix 2 (dark brown—see *Mixing your colors*), paint the center stem and the beginning of each main branch, blending into the Burnt Umber. Leave a thin white line on the thickest part of the center stem for a highlight to give it a curved form. When everything is dry, you can use your kneaded eraser to gently remove any remaining pencil lines. Trim it down and pin it up on your wall or frame it and most importantly, take time to appreciate what you have achieved!

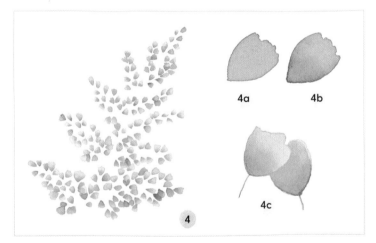

4a 4b

4c

4

When painting your fern, you will probably find you are constantly needing to remove excess water or having to lift paint from the paper to control the paint within the leaves. Keep your paper towel handy to make it easy to do this.

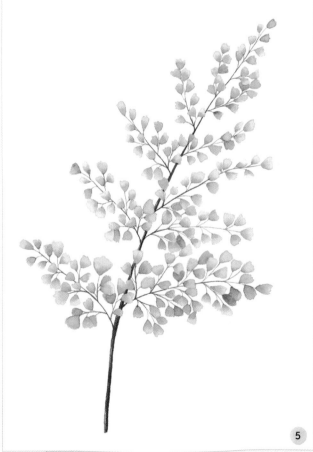

5

Turtle

There is something about turtles that makes them so majestic and relaxing to look at. If you think this project looks a little bit daunting, don't be put off! It is one of the longer projects in this book but that is due to the amount of repetition involved rather than complexity. It's a great project to put some music on with and get really involved in!

You will need

- Watercolor paper
- Water
- Paper towel
- Pencil & eraser
- Opaque white paint or gel pen

BRUSHES:

- Size 2 round brush
- Liner brush

PAINTS:

Winsor Lemon · Permanent Rose · Burnt Umber

Indigo · Ivory Black

Mixing your colors

For the orange (Mix 1), add Permanent Rose to Winsor Lemon. For the dark brown (Mix 2), add a little bit of Indigo to Burnt Umber. For the gray (Mix 3), add a little Permanent Rose and a little Winsor Lemon to Indigo.

Mix 1 — WL + PR

Mix 2 — BU + In

Mix 3 — PR + WL + In

DRAWING THE TURTLE

1 To draw the turtle, start with the outline of the shell in a kind of semi-circle shape with a curved base. Then draw the head and neck and continue towards the shell for the belly. You can then draw in the arms and erase the line where the front arm sits over the belly. Finally, draw in the back leg and add in the eye.

2 Once you have drawn the overall shape, you can draw the smaller sections within the shell. Start with the rectangular shapes along the bottom edge, leaving a thin gap between them. Then draw in the larger shapes above. If you drew this straight onto your watercolor paper, make sure you remove any unwanted pencil lines before you start painting.

You may want to draw the turtle onto a piece of regular paper first, to get the shape right, and then trace it onto your watercolor paper.

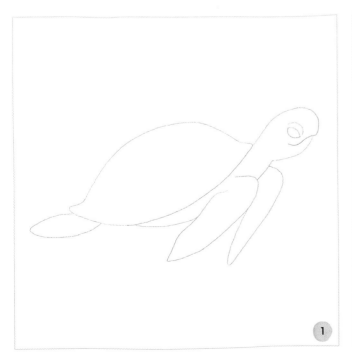

1

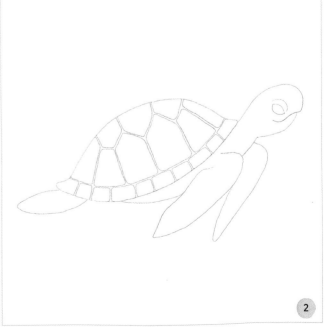

2

PAINTING THE TURTLE

3 Using your size 2 round brush, paint the shell. This is the part that will take the longest, so don't rush it; paint one section at a time using the wet-on-wet technique. Prepare your colors on your palette before you start: Winsor Lemon, Mix 1 (orange: see *Mixing Colors*), Burnt Umber and Mix 2 (dark brown). Start with the yellow, leaving a patch of white paper for a highlight in the top right corner **(3a)**. While that is still wet, add some orange, leaving some of the yellow showing through near

the highlight **(3b)**. Next add in the Burnt Umber around the edges **(3c)**. You can tip the paper for a few seconds to let the brown run towards the center of the section. Finally add some dark brown to the very edges **(3d)**. This deeper color will add some depth and dimension to each part of the shell and make them appear slightly curved. Repeat for each section in the shell.

4 Use a very diluted Burnt Umber around the edges of the head, back leg and the front arm that is closer to us. Use a very diluted gray mix (Mix 3: see *Mixing Your Colors*) for the edges under the belly, chin, and the arm that is farther away for a bit more of a shadow. Add a diluted yellow around the top of the eye. Leave to dry before moving on to step 5.

5 Paint a mosaic-like pattern using Burnt Umber on the back leg, closest front arm and the head around the eye. On the arm and leg, paint larger shapes at the edges and smaller shapes in the center. Add some smaller marks

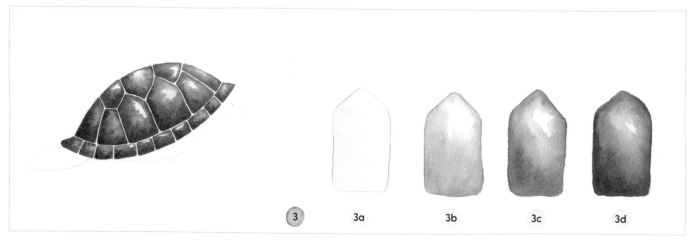

3 3a 3b 3c 3d

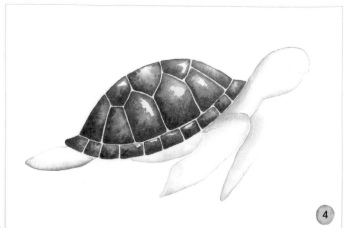

4

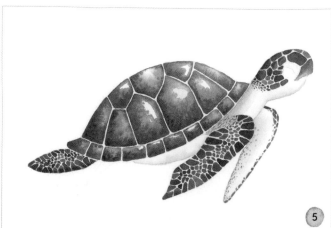

5

where the arm meets the body. For the head, paint the shapes smaller as they go down the neck. On the arm that is farthest away, paint some small shapes along the right edge and then some smaller marks on the left edge.

6 Using Ivory Black, paint the eye leaving a small speck of white paper showing through for a reflection. Paint a thin line above and below the eye and some small dots above the eyelid. Paint a thin curved line for the mouth.

7 Using your liner brush or smallest brush, paint some fine lines and dots along the skin. Use a diluted Indigo for the belly, neck, chin, and arm that is farthest away, and Burnt Umber for the part of the neck closest to the shell.

8 With your liner brush, add some very fine white lines around the edges of each section in the shell, pointing towards to center. These subtle details will add a lovely finishing touch to your painting.

This is one of my favorite projects and one that I was most excited to share with others when I had finished it—I hope you have enjoyed it too! Put it up somewhere on display to make you smile.

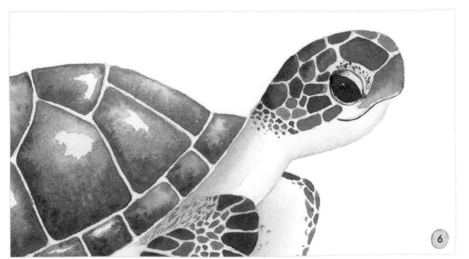

Turtles have notoriously grumpy faces, but I decided to add a little upturn to this guy's mouth to make him look a bit happier and cuter!

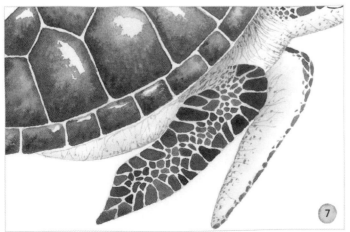

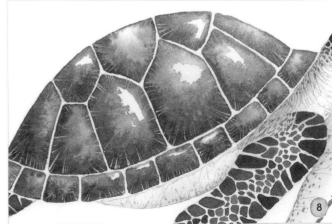

MORE INSPIRATION: *Patterns*

Patterns are a wonderful way to turn watercolor into a mindful activity. From simple doodles to finished pieces, the process can be incredibly calming, free from the pressure of painting a particular subject. They are great for practicing brush strokes and different techniques, building your confidence with watercolor. You can make bookmarks, cards, and gift tags by painting simple lines or shapes, or experimenting with pattern combinations. These are also a lovely way to play around with color palettes to discover some beautiful harmonies. If you struggle for inspiration with painting patterns, just start with something simple. Sometimes the best inspiration comes during the process itself and the best results can develop organically while you are painting.

Vary the values, alternating between simple lines, dots, dashes, and blocks of color.

Use a flat shader to paint zig zag lines using an analogous color scheme.

Alternate between concentrated and diluted circles, touching so they bleed together. Once dry, add patterns on top.

Make it as easy as possible for yourself to make time to paint by keeping a pile of blank bookmarks and gift tags ready to go!

Paint the lines first and then leaf shapes on either side.

Paint simple lines, focusing on your breathing to relax.

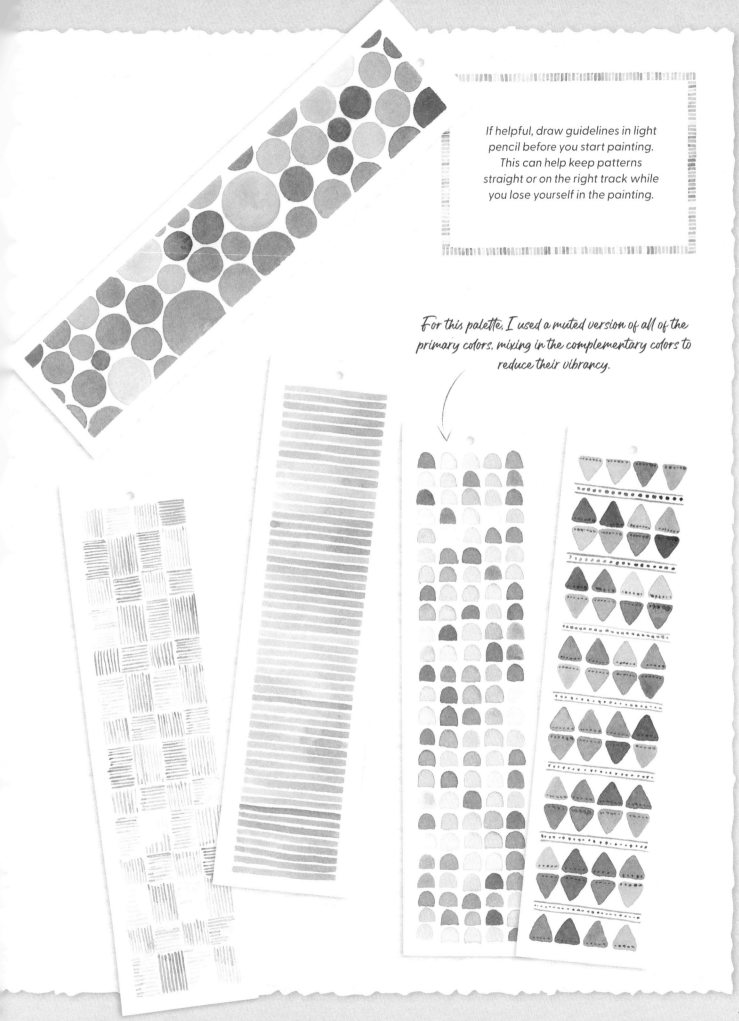

If helpful, draw guidelines in light pencil before you start painting. This can help keep patterns straight or on the right track while you lose yourself in the painting.

For this palette, I used a muted version of all of the primary colors, mixing in the complementary colors to reduce their vibrancy.

MORE INSPIRATION: *Mosaics*

Mosaics are a perfect way of painting for relaxation. The process is repetitive and calming, with minimal technique involved. Simply draw the outline of a subject or shape lightly in pencil, then divide it into smaller shapes. You can use either the wet-on-wet technique or a flat wash to fill in each section. Choosing a harmonious color scheme will also make the process visually calming. Mosaics can be a great project to complete over a period of days or weeks, painting for just twenty minutes or so a day to fill in a section. Alternatively, it's a wonderful way to lose yourself in painting for a couple of hours.

Choose a simple shape like a heart and divide it into different sections. Fill each section using a variety of greens from yellow-greens to blue-greens. Vary the values of each color for a contrasting, yet beautiful and harmonious result.

Divide the lighthouse into sections, with brick-like shapes. Choose your favorite colors for the bolder stripes, using light grays and blues for the white areas.

For more complicated subjects, sketch the outline out onto a piece of normal paper first, before dividing it into sections and shapes. Finalize it with a pen and then trace over it onto your watercolor paper.

For a more detailed mosaic, choose a subject like an owl, dividing it into sections of color for the eyes, ears, wings, belly, and talons.

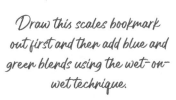

Draw this scales bookmark out first and then add blue and green blends using the wet-on-wet technique.

A mosaic letter would make a lovely piece of wall art for a child's room or a gift for friends and family.

ABOUT THE AUTHOR

Sharone Stevens is a primarily self-taught watercolor artist who has built a successful online business teaching aspiring artists across the world how to paint. She initially started painting as a teenager at college, but found herself following a different path at university, studying Psychology. 15 years later, after the birth of her son, she re-discovered her love of watercolor and started sharing her work on Instagram, which led to teaching online classes. Using art as a form of therapy and self-care, she is now determined to share her passion for painting and how it can be used for relaxation by inspiring, motivating, and educating others. She is a Top Teacher on Skillshare and an ambassador to Princeton Brush Company. She lives just outside London with her husband, son, and two cats.

Website: sharonestevensdesign.co.uk

Instagram: @sharonestevensdesign

ACKNOWLEDGMENTS

This book was a dream of mine that I would not have been able to complete on my own. Thank you to my husband for all of the support and advice you have given me and your endless belief in me. Thank you to my son for inspiring me to follow my passion; I hope I can do the same for you as you grow up! Thank you to my parents, my family, and to everyone else who has supported me in writing this book; I am so grateful for your feedback and encouragement throughout this journey. Finally, thank you to Ame and the team at David and Charles for approaching me and believing in me, helping to turn all of my ideas into something I am so proud of.

Sharone would love to see the paintings you create using this book!

Tag them on social media using #watercolorforthesoul

INDEX

A DAVID AND CHARLES BOOK
© David and Charles, Ltd 2022

David and Charles is an imprint of David and Charles, Ltd
Suite A, Tourism House, Pynes Hill, Exeter, EX2 5WS

Text and Designs © Sharone Stevens 2022
Layout and Photography © David and Charles, Ltd 2022

First published in the UK and USA in 2022

A catalogue record for this book is available from the British Library.

ISBN-13: 9781446308998 paperback
ISBN-13: 9781446381281 EPUB
ISBN-13: 9781446381274 PDF

This book has been printed on paper from approved suppliers and made from pulp from sustainable sources.

Printed in China by Leo Paper Products Ltd for:
David and Charles, Ltd
Suite A, Tourism House, Pynes Hill, Exeter, EX2 5WS

10 9 8 7 6 5 4

Publishing Director: Ame Verso
Editor: Jessica Cropper
Project Editors: Jenny Fox-Proverbs and Claire Coakley
Head of Design: Sam Staddon
Designers: Sarah Rowntree and Lucy Waldron
Art Direction: Sarah Rowntree
Pre-press Designer: Ali Stark
Illustrations: Sharone Stevens
Photography: Jason Jenkins
Production Manager: Beverley Richardson

David and Charles publishes high-quality books on a wide range of subjects. For more information visit www.davidandcharles.com.

Share your makes with us on social media using #dandcbooks and follow us on Facebook and Instagram by searching for @dandcbooks.

Layout of the digital edition of this book may vary depending on reader hardware and display settings.